M O D E R N
DRAWING

A contemporary exploration of drawing and illustration

CHELSEA WARD

Brimming with creative inspiration, how-to projects, and useful information to enrich your everyday life, Quarto Knows is a favorite destination for those pursuing their interests and passions. Visit our site and dig deeper with our books into your area of interest: Quarto Creates, Quarto Cooks, Quarto Homes, Quarto Lives, Quarto Drives, Quarto Explores, Quarto Gifts, or Quarto Kids.

© 2018 Quarto Publishing Group USA Inc.
Artwork and text © 2018 Chelsea Ward

First Published in 2018 by Walter Foster Publishing, an imprint of The Quarto Group. 6 Orchard Road, Suite 100, Lake Forest, CA 92630, USA. **T** (949) 380-7510 **F** (949) 380-7575 **www.QuartoKnows.com**

Walter Foster Publishing titles are also available at discount for retail, wholesale, promotional, and bulk purchase. For details, contact the Special Sales Manager by email at specialsales@quarto.com or by mail at The Quarto Group, Attn: Special Sales Manager, 401 Second Avenue North, Suite 310, Minneapolis, MN 55401 USA.

ISBN: 978-1-63322-492-6

Digital edition published in 2018
eISBN: 978-1-63322-493-3

Acquiring & Project Editor: Stephanie Carbajal
Page Layout: Erin Fahringer

Printed in China
10 9 8 7 6 5 4 3 2 1

TABLE OF
CONTENTS

BONUS MATERIAL!
Looking for more inspiration and drawing tutorials? Visit www.quartoknows.com/page/modern drawing **for free content downloads!**

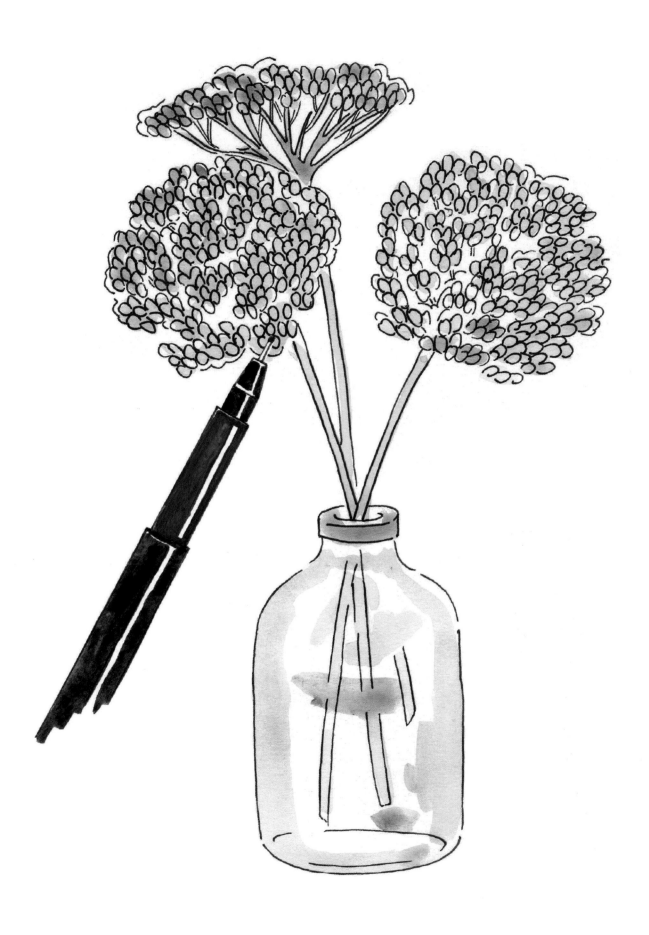

INTRODUCTION

When my students ask what my last name is, I tell them, "It's 'draw'—backwards." Besides being part of my name, drawing has always been an important part of my life. Some of my earliest memories involve doodling on a yellow legal pad with a pen I snagged from my mom's purse...with crayons on the backside of a paper menu at a restaurant...on the metal cabinets in my dad's shop with chalk.

Years later, and I'm still an avid drawer. From "100-Day Drawing Challenges" to filling a hand-bound sketchbook within a month while traveling abroad, drawing is a huge part of my life. It has taken years of practice, countless erased drawings, and many, many embarrassing sketchbooks to develop my own style, grow my skills, and train my eye.

Drawing is a unique type of art making, because it's not limited to just one tool. In my studio, I have a stash of pens in varying tip sizes and colors, along with brushes, inks, markers, watercolor pencils, and more. When traveling, I bring along my trusted fountain pen and water brushes. For much of my work, I finish the piece with watercolors—or even digitally on my computer—but everything starts with a basic pencil drawing.

Just like nearly all art forms and media, drawing starts with the most basic of materials—a simple pencil and a piece of paper. Drawing is a fundamental skill that is the foundation for a whole slew of other art-making methods: watercolor, sculpture, digital art, chalk lettering, oil painting, architecture, comic book illustration, and more. Compared to others, drawing may not be the flashiest of media, but it is arguably the most important.

For "modern drawing," I like to think that the rules are meant to be tested, erased, and then tested again. But in order to test those boundaries, you need to understand the rules first. In this book, you'll find instructions for drawing basics—everything from starting with a simple line to working with shapes to building a complex figure. We'll go through the basics of drawing and work our way through the materials and different methods of drawing various subjects. We'll play with a variety of materials and experiment with different ways to use them. Drawing shouldn't just be limited to one tool, or even to just dry media. A fountain pen sketch can go from just a drawing to an ink-and-wash painting with the help of a paintbrush and a little water. Combining watercolor and pen can lead to unique multimedia discoveries. I'll also show you my tips and tricks for keeping a sketchbook and building your skills and confidence with modern drawing—in the studio or on the road.

SUPPLIES

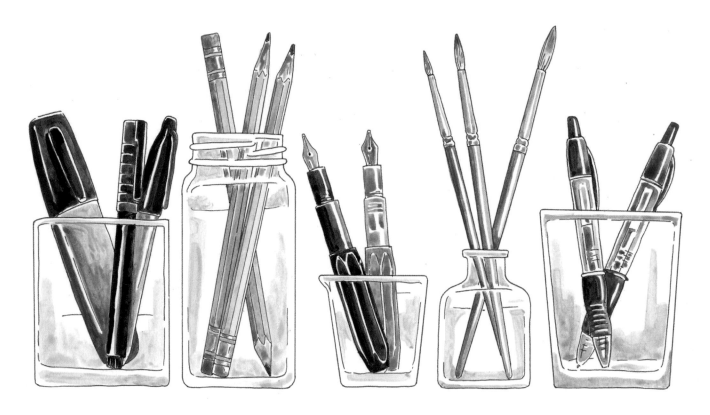

With modern drawing, the options are endless, especially when it comes to supplies. There are so many different and unexpected supplies that you can use—calligraphy brushes, fountain pens, felt-tip markers, charcoal pencils, a stick with loose ink, and more.

PENCILS

There are a variety of good pencils, but never underestimate the usefulness of a basic #2 pencil! There are limits to how dark you can shade with a #2, but for preliminary sketches or just to get an idea down before you forget (or your subject walks, drives, or runs off), #2 pencils are an invaluable tool.

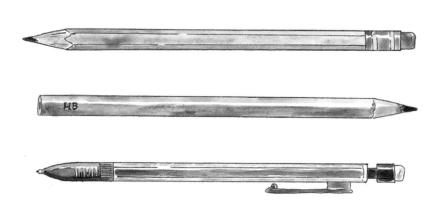

I use a mechanical pencil for much of my sketching and doodling. Especially when traveling, eliminating the need to carry around a sharpener can be very helpful! No need to track down a trashcan for pencil shavings or worry about the sharpener opening in your bag during transport. Mechanical pencils are always sharp and easily reloaded with more lead. They are also limited in how dark you can shade, like their cousin the #2, but they're still a great basic to have on hand.

PENS

When it comes to shopping for artist pens, it can be overwhelming, since there are so many great brands. I recommend exploring as many as you can! Each brand has their own variety of tip sizes and widths, as well as different colors to choose from.

WATERPROOF OR WATER-SOLUBLE PENS Different drawing scenarios require different kinds of pens. A good, fine-point waterproof pen is a great tool for nearly every drawing situation. I often use these when making a sketch that I don't have time to watercolor on-site. Since they're waterproof (or permanent), you don't have to worry about watercolors (or rogue raindrops, if you're drawing outside) making the ink run or smear. Waterproof pens can also be used on top of dry watercolor paintings or pencil sketches to add details or emphasis.

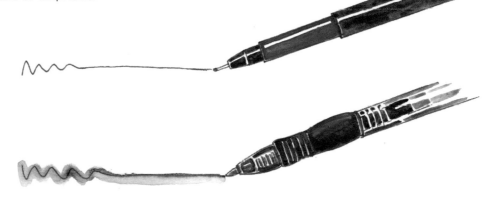

On the other side of the pen spectrum are water-soluble pens—pens with ink that isn't waterproof. While these may seem messier and less practical, with a few brushstrokes of water, you can turn any drawing into an ink-and-wash painting!

FELT-TIP OR BALLPOINT PENS Felt-tip pens are great for filling in large spaces with lots of ink quickly, but it can be tricky to control the line thickness. These are still great pens to have for gesture drawings or quick sketches, in lieu of a pencil.

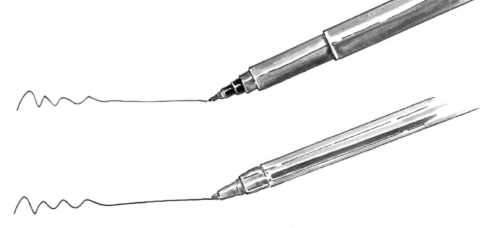

Ballpoint pens are a lot of fun to draw with as well. Since the ink flows slower and more evenly, you can control the line thickness better and slowly build up the shadows or layers in a drawing. Ballpoint pens also come in very fine points, so you can draw very fine details with just a basic pen. And, since many ballpoint pens are water-soluble, you also have the option to turn them into ink-and-wash paintings.

FINE-TIP, WIDE-TIP & BRUSH-TIP PENS Each brand of pen has its own scale for measuring tip sizes and types. They are available in everything, from fine or extra-fine points all the way to medium, wide, and brush tips.

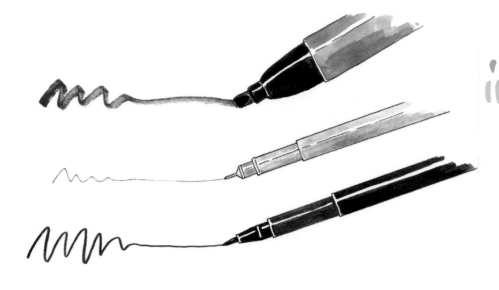

Fine-tip pens or markers are wonderful for very detailed drawings. With the fine tip, you can outline shapes and create a very intricate line drawing. However, they're a little too small to fill in a large area with shadow, which is where a medium or wide tip comes in handy.

Medium- or wide-tip pens are fantastic for many types of drawing. They're great when you need to fill a larger area with color, and they're also great for quick sketches or gesture drawings. The larger pen size can make them a bit clumsier to work with, but the bigger tips produce lovely, loose results.

Brush-tip pens have many great uses too. They're especially fun, because you can change the width of the stroke depending upon how much pressure you apply to the brush tip. With different sizes of brush tips, you can do everything from mimicking a brush-and-ink painting to fine calligraphy lettering, and even loose gesture drawings.

FOUNTAIN PENS Don't let the old-fashioned charm of these pens scare you away! Fountain pens are one of my favorite travel tools for drawing. They have great fine points that can give you perfect fine lines for any drawing. Most brands carry a variety of colored ink cartridges, so you can have multiple color options with a quick cartridge change. When I'm traveling, I pack three travel-sized fountain pens at a time with blue, black, and brown ink.

Another fun perk of fountain pens is the ability to add a little water. Just by dipping a paintbrush in water, you can loosen up the ink from the fountain pen and turn your drawing into an ink-and-wash painting.

PAPER

In my personal sketchbook, I have everything from drawing paper and graph paper to watercolor paper, kraft paper, and multimedia paper. Sometimes I don't know what I'll want to draw with until I find the perfect subject!

When getting started, a good mixed-media paper gives you plenty of room to experiment with different techniques and media. Mixed-media paper over 90 lbs. provides a good surface for pencil drawings, in addition to pen and marker. The heavier paper weight also gives you the option to incorporate watercolors or ink without worrying about the paper rippling or warping from the added moisture.

Drawing paper is always a good choice as well, and the thicker the better. An 80-lb. paper is perfect to get started. You'll be able to use pencil, pen, charcoal, markers, and even some very light washes with this paper.

Other good paper options to explore include:
• Kraft or brown butcher paper
• Watercolor paper (140-lb. cold-pressed is my favorite)
• Graph paper (great for practicing architectural drawings and perspective)
• Toned or colored paper

Once you have your supplies, it's time to play! Each drawing tool has different quirks and possibilities, so it's fun to explore and experiment. Try different mark-making exercises, shape-drawing, pattern-making, and more on the paper to see which you prefer, and with which tool!

OTHER DRAWING TOOLS

Additional basic tools you may want to add to your basic toolbox include:
• Erasers
• Pencil sharpener
• Paintbrush (for making those pretty washes)
• Pouches or containers for organizing your drawing tools

DRAWING BASICS

When learning to draw, there are some very important things to remember while you're just getting started.

• **DRAW WHAT YOU SEE.** Seems simple, right? But it's not always so easy. When we're drawing, it's easy to forget to fully observe the subject for all its individual details. Instead, we let our brains fill in the blanks for us, losing all the details unique to that specific subject. When drawing from life, make sure to keep looking back at your subject as much as you can. Keeping your eye informed of what you're drawing stops your mind from filling in the gaps with what it thinks it looks like. The imagination is a great tool, but drawing from life will build your drawing vocabulary and make your imaginative drawings more realistic!

• **SKETCH LIGHTLY.** We all make mistakes, especially when drawing. Make sure to sketch as lightly as possible, so if any mistakes do occur, you'll be able to erase them more easily.

• **WAIT TO ERASE.** You're bound to make mistakes—just make sure you're learning from them as you go. Before you erase a rogue mark or line, correct it first! The tendency is to erase it immediately, but often artists just draw the same mistake again...and again...you get the idea. By paying attention to the mark you're trying to fix, you're more likely to correct it the first time!

• **BE PATIENT.** Michelangelo didn't carve *David* in one day, and drawing skills will not develop in one day either. Drawing can be tedious, and building your skills takes time, so be patient and go at your own pace.

• **BE KIND.** Especially if you're a beginner, please be kind to yourself. Being overly critical of yourself while learning a new skill is counterproductive. Be your number one fan!

Any object, no matter how complex or odd, is made of simple shapes. Circles, triangles, squares, rectangles, ovals... these basic shapes can be used to simplify and break down any object.

Pick an object near you (a shoe, potted plant, lamp, chair, etc.), and start breaking it down into basic shapes. No objects nearby? Grab a magazine and find an image there!

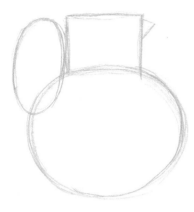 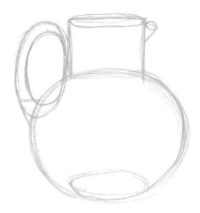 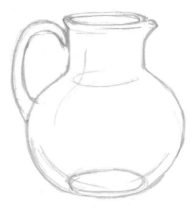

Start by looking for the largest shapes, or the outline of the object, and work your way inward. Note that some outline shapes may overlap each other.

Once you identify the largest shapes, start looking inside. Are there smaller shapes within those initial large shapes? Start sketching those in lightly; don't be afraid of overlapping lines.

Once you have all the secondary shapes in place, start connecting them. Sketch lightly, and add any curves or angles where the shapes meet. You can also start erasing any extra lines from the overlapping shapes.

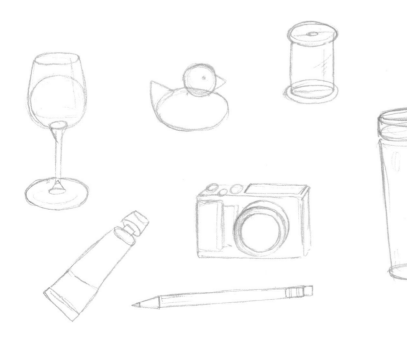

Start looking for shapes all around you! All objects, plants, animals, and people are just made of basic shapes.

MARK-MAKING &
LINE WORK

There are countless ways to make marks and lines on the page. Some techniques are more suited to certain drawing scenarios, but they can all be adapted.

These different techniques for mark-making will come in handy for shading, adding texture, and making your drawings appear more three-dimensional.

STIPPLING Stippling is a lot of fun, and it's a great way to slowly build up shadows in a drawing. It can be done with pencil, but it's faster when using a larger felt-tip pen.

To stipple, gently press the tip of your felt-tip pen or marker to the paper over and over to create many tiny dots. Pushing the pen repeatedly and hard dulls the tip faster, so be gentle to preserve the pen tip.

The closer the dots are, the darker the shading will appear. The farther apart the dots are, the lighter the shading appears.

HATCHING Hatching is a great drawing method when you're pressed for time or just making a quick study and need to indicate the curve of an object or where to shade later. And it can be done with any tool!

To make hatch marks, grab your drawing tool and make short, quick lines. Like stippling, the closer the lines are together, the darker it will appear. The farther apart the lines are, the lighter it will appear. Try curving the hatch marks to give the illusion of shape. If using a pen, add more pressure to the pen as you draw the lines to make the hatch marks thicker.

Hatching is also a great technique when you want to accent the shape or a detail on an object, particularly in botanical drawings.

CROSSHATCHING Crosshatching is similar to hatching, but the lines overlap. This technique builds up shadows even faster than stippling or hatching. Crosshatch marks can go in different directions too, so you can draw curved lines to give the illusion of a shape.

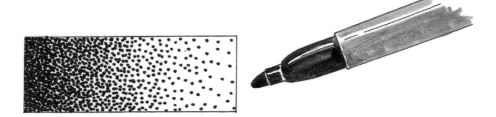

Here are a few ways to practice these techniques.

GRADIENT SCALES Draw a rectangle about 1" wide and 3" long, and start shading it in from left to right, with either stippling, hatching, or crosshatching. Make your marks close together, with very little paper showing, toward the left side of the scale. As you move to the right, gradually spread out the marks to show more paper. By the time you reach the far right, there should be just a few marks and mostly paper showing.

A great way to test if you need more dots or lines is to squint your eyes. When you squint your eyes, you'll be able to see the gradient change and any places that may need more shading.

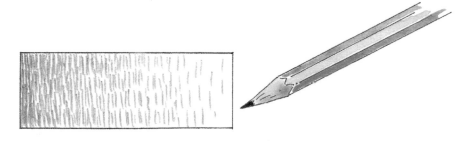

STIPPLE GRADIENT

HATCH GRADIENT

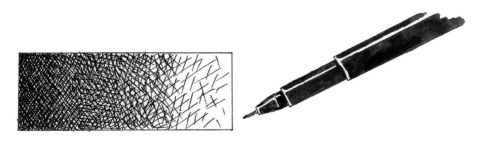

CROSSHATCH GRADIENT

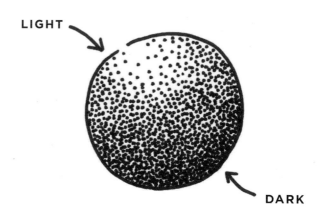

SHAPE SHADING After practicing stippling, hatching, and crosshatching in gradients, it's time to build those skills with shapes.

LIGHT

DARK

Draw a circle in pencil first. Pretend there's a light pointing at it from the top left corner of your paper. The darkest point should be opposite of that, along the lower right side of the circle. Start using stippling, hatching, or crosshatching to shade in the darkest shadow, leaving more paper between your marks as you get closer to the top left.

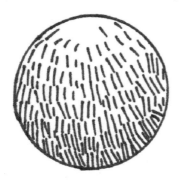

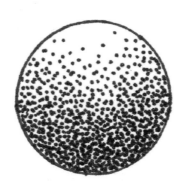

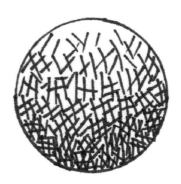

If using hatching or crosshatching, round the lines to mimic the curve of a circle to make it appear more three-dimensional. You can use as many different pens or pencils as you like to test out how each one works with these techniques.

Once you've shaded in circles with each technique, try different shapes! Change the direction from which the light is coming to practice shading in different directions.

You can also use different pens and techniques in different shapes to test what kind of marks each pen makes.

NEGATIVE SPACE Another good technique to explore is playing with negative space. Negative space is the shape or area left by another shape. For example, hold up your hand and spread your fingers apart—the negative space between your fingers looks like a triangle!

You can use mark-making to leave a silhouette or outline of another shape. To do this, sketch the shape you want to make in pencil first. Instead of making your marks inside that shape, make them around the outside of the shape.

Once you've practiced using these techniques in gradient scales and basic shapes, grab some objects around you and draw from life. Fruit, flowers, coffee mugs, jars—anything you like!

When drawing more complex objects, break them down into their basic shapes first, and sketch lightly in pencil. Once you're happy with the shape, start adding stipple, hatch, or crosshatch marks with your pencil or pen. Pay attention to where the light is coming from and any shadows the object casts.

 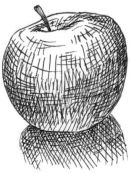 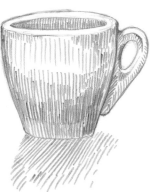

LINE DRAWING

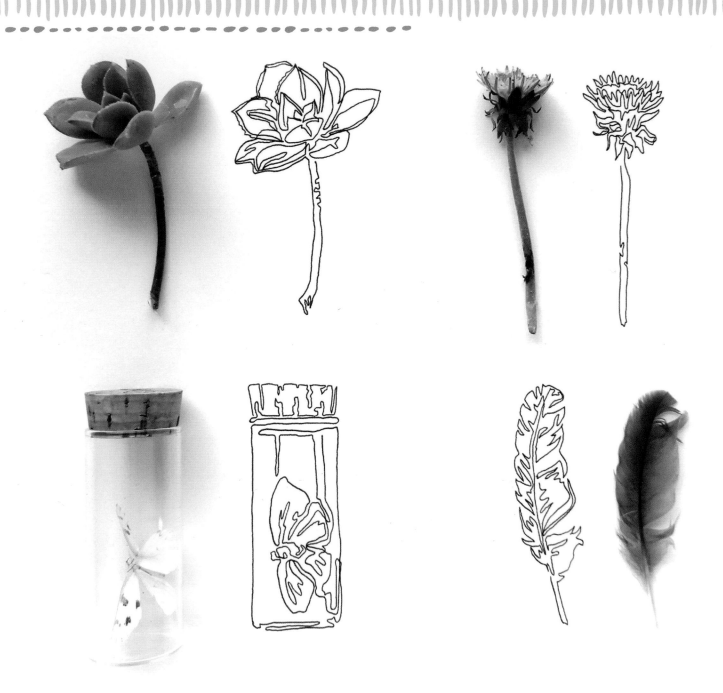

CONTOUR DRAWING Contour drawing is a great way to warm up, loosen your drawing, or just study an object. Get your pencil or pen and start drawing the object without picking up the drawing tool from the page!

Start in the center of the object, and work your way out toward the edges. Let the lines crisscross and overlap across the page to get all the shapes in. Overlapping the lines multiple times makes it appear shaded, like crosshatching.

Want an added challenge? Try a blind contour drawing! Pick your subject and make your contour drawing without looking at the page—not even one peek! The results will often be strange and outlandish, but it's a great technique to loosen up and study a subject before starting a more detailed drawing.

GESTURE DRAWING Gesture drawings can be done with any medium (even ink and wash). This is a fantastic method to practice working quickly and simplifying your drawings. Gesture drawings are meant to be quick and convey as much information as possible in as few marks as possible. They take a lot of practice, but they're a great exercise to train your eye and speed up your hand.

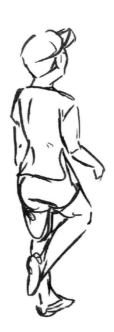
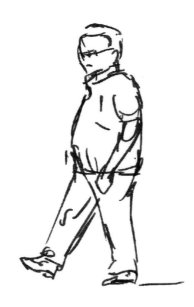
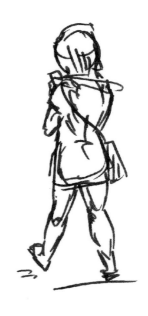

Gesture drawings are particularly useful when drawing moving subjects. They can be loose and sketchy and capture the movement more accurately. Lines can overlap, like contour drawings, and be flowy to show the movement of the subject.

Before you start drawing, observe your subject. Is the weight more to one side? Is it catching the light a certain way? Give yourself a time limit for making your marks, so you don't overwork the drawing.

Work quickly to make marks on the page to convey size, weight, movement, shape, and more. If an object is shaded or heavier on one side, your marks should reflect that and be larger or darker along that side. The same applies to lighter areas—the marks should be thinner or taper off. If you're using a pencil, try holding on to the edge of the lead to have a wide edge for marking darker areas. Gesture drawings are perfect for using hatch marks too. Hatch marks help convey shape, movement, and shading.

KEEPING
A SKETCHBOOK

Learning to keep a sketchbook can sometimes be harder than drawing itself. But I fully believe that it's a worthwhile habit to form and keep. Not only will you build your technique and confidence, but you will keep your skills sharp and fresh!

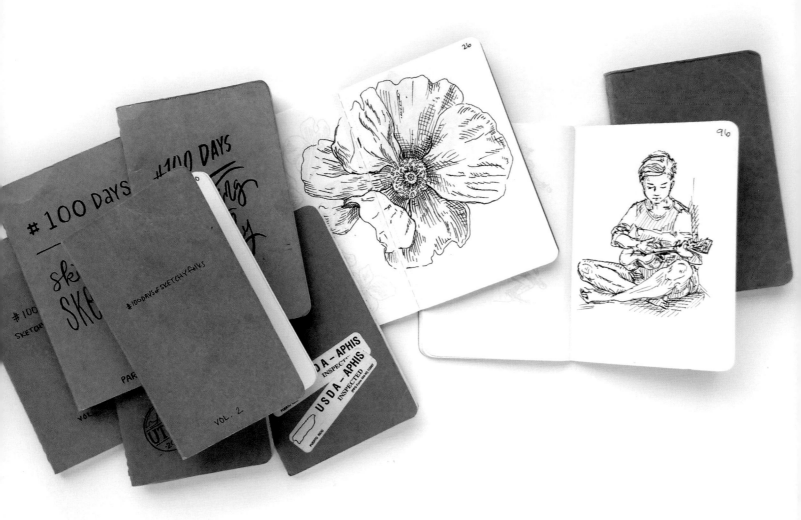

Remember that a sketchbook doesn't have to be perfect. When we visit art museums, we don't see the hundreds of sketches that led to the final masterpieces hanging on the gallery walls. Sketchbooks should be exactly what the name implies: sketchy! Your sketchbooks should be loose, and even messy. They're places for mistakes and learning and hashing out new ideas until they're ready to become that final masterpiece.

One great way to get into the habit of keeping a sketchbook is give yourself a challenge...a couple weeks, 30 days, or even 100 days in a row of drawing! You can draw anything—your kids, different plants in your garden, your cat, or just something that catches your eye each day. At the end of a drawing challenge, I often feel like there's something missing from my daily schedule. Once drawing daily becomes part of your routine, keep it up. There's nothing wrong with a 365-day challenge!

TIPS FOR A SUCCESSFUL DRAWING CHALLENGE

- **KEEP IT REACHABLE.** Yes, it's a challenge and it should be challenging...but it should also be reasonable. If you know that you won't have an hour to spare between getting to the gym, work, the grocery store, and cooking dinner, don't set the bar so high that you set yourself up for failure. The fastest way to get burned out on a drawing challenge is feeling like you failed by day three. Keep it to 10-15 minutes—something you can do over your morning coffee or before you head to bed (instead of checking social media just one last time!).

- **MAKE IT SMALL.** For my own drawing challenges, I prefer to use pocket-sized sketchbooks. This way, they're in my purse or pocket at all times. The smaller size also makes the idea of 100 sketches in a row less daunting.

- **LEARN FROM EACH PAGE.** Don't beat yourself up over a sketch that didn't go as well as you had hoped. Think of each page as a building block toward your next drawing. Figure out what didn't go well, and incorporate what you learned in your next sketch.

- **STAY ACCOUNTABLE.** Tell someone you're doing a drawing challenge, and maybe invite them to join in. Share your sketches and your progress online, on social media, or even with your best friend. You can even make a hashtag to share and have others follow your progress and cheer you on.

DRAWING
ON THE GO

My sketchbooks from my travels abroad are some of my favorite souvenirs I've brought home. I can flip to any page and likely tell you what city it was sketched in, who was with me, and possibly what gelato I had that day!

Sketching builds a memory stronger than any quick snapshot on your phone will ever provide. When sketching a scene, you're observing everything more closely and absorbing more details than you can with a quick click of the phone. Yes, a phone is faster and often more convenient, but I personally regret the sketches I didn't make more than the photos that I missed.

Drawing on the go can seem daunting, but with a little preparation, you can easily turn any space into a mini studio!

My travel drawing kit is filled with miniature versions of my favorite go-to drawing tools: pencil, eraser, fountain pen, water brush, and a watercolor set. Having smaller versions of your drawing tools makes it easier to keep them with you all the time. Whether in your back pocket or a pouch in your carry-on, having travel-sized materials can make the difference between coming home with a sketchbook full of memories or empty pages.

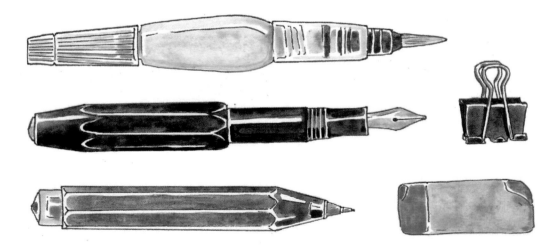

The staples I always have in my purse or travel kit are:
• Small water brush: Water brushes are amazing tools, because they eliminate the need to carry a jar of water for painting. They come in a variety of sizes, but this travel-sized one is always with me.

• Small fountain pen: I have a fine-point pen with black, blue, and sepia ink cartridges.

• Small mechanical pencil

• Tiny binder clip, perfect for holding down pages on windy days

• Small eraser

Of course, not all materials are available in a travel or miniature size, but I do my best to stay smaller with the basics to leave room for the tools that can't be small.

For quick trips, I use a smaller sketchbook (6" x 9") that I can keep in my purse or backpack. When I'm traveling abroad, or I have a month or more to sketch, I often pack a full-sized sketchbook (8.5" x 11") to give myself plenty of room and options for long landscapes, tall buildings, and any scene in between.

Before a long trip, I like to hand-bind a sketchbook filled with an assortment of paper types—everything from graph and drawing paper to watercolor and toned paper. The variety of paper options keeps me from getting burned out on just one medium and gives me some flexibility with my materials. When you get a new sketchbook, don't be afraid to glue in some different types of paper! Cut toned paper, graph paper, scrapbooking paper, old sheet music, or even butcher paper down to size and glue them inside.

TIPS FOR DRAWING ON THE GO

- **KEEP IT SMALL, KEEP IT ON YOU.** I can't tell you how frustrating it is to be out and about in a new town and not have my sketchbook and pen on hand. Especially when the most perfect vintage car parks across from me! Keeping your supplies small helps keep your studio portable for any time the moment strikes to sketch!

- **WORK QUICKLY.** When drawing people or cars or anything that moves, there's always the risk that they'll leave before you can finish. Anticipate that your subject might leave, and work quickly and loosely to get basic shapes or outlines in before moving on to the minute details. There's nothing more frustrating than having a perfectly drawn shoe with no person to attach it to when they've walked off.

- **SEEK THE SHADE.** As much as I love to sketch fast, sometimes I want to linger in a spot and capture every detail. This is always more comfortable in a shady spot. When there's no shade around, make sure you've got some sunscreen or a hat to protect yourself from sunburn.

- **TAKE A PHOTO.** I'd always like to draw from life, but sometimes it's not an option. The weather may take a turn for the worse, or the light will drastically change, or your subject simply walks or drives away! Having a photo for reference helps in situations when you can't finish your drawing on-site. It's a good habit to always have your phone or a camera with you when drawing. As soon as you find your ideal drawing spot, snap a quick photo to refer to later...just in case!

If I know I won't have enough time to sketch and color a drawing, sometimes I'll sketch in pencil and draw the final lines with waterproof pen. With the help of my photo, I can add color later, instead of having to rely on memory alone.

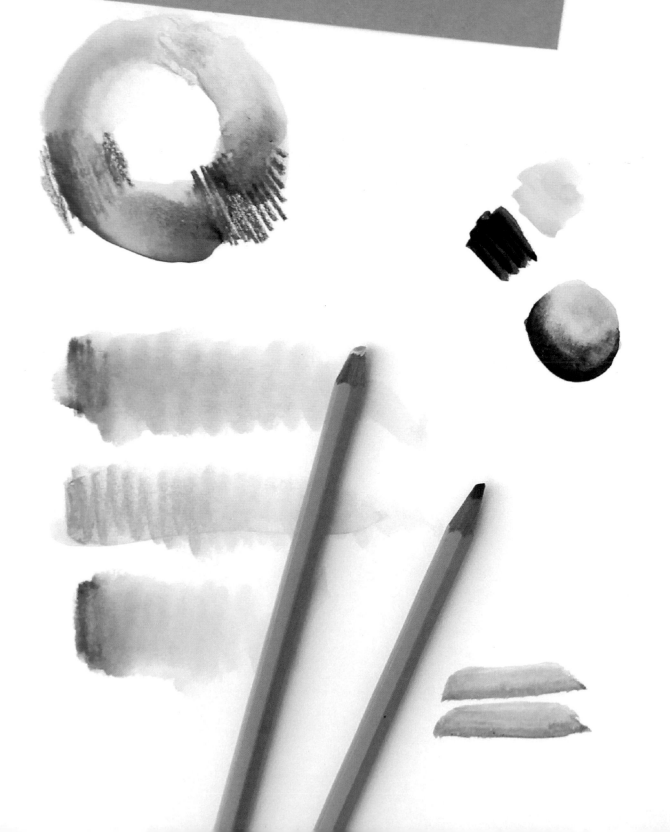

ADDING COLOR

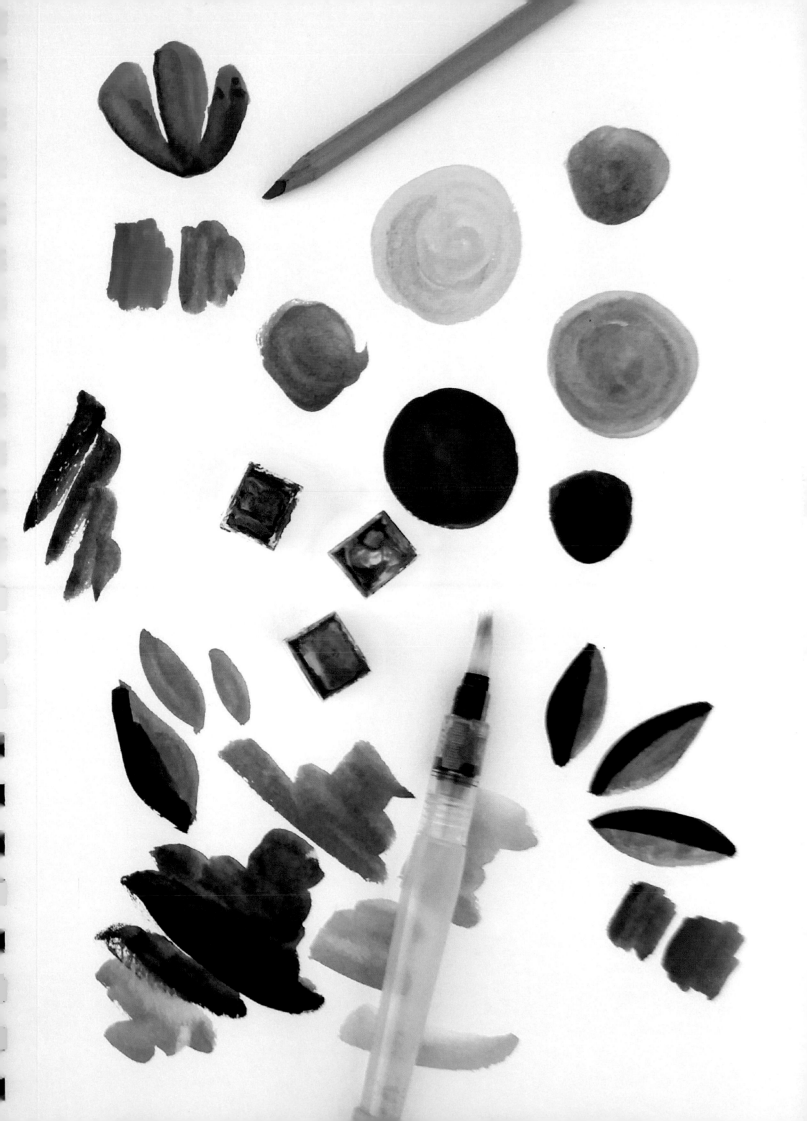

COLORING
TOOLS

There are myriad tools you can use to add color to your drawings—everything from colored pencils and watercolor pencils to markers, ink washes, and more!

When it comes to adding color to a drawing, I'm a little biased towards watercolors. I have a travel watercolor set with me at all times! Watercolors are especially great for travel, because they're quick to dry and allow for layering.

Not quite ready to dive into watercolors? Watercolor pencils offer a great middle ground to learn this medium. Even with a basic set, you can add great splashes of color to a drawing and have it still feel like drawing. Then, when you're ready to loosen it up, a little bit of water goes a long way to blend colors together.

Regular colored pencils are also a fun tool for adding color. When shopping for colored pencils, the cheaper the colored pencil, the poorer the quality of color and shading you'll have. A good mid-priced set will give you plenty of colors to blend together well, without breaking the bank.

COLORING
TECHNIQUES

Adding color to your drawings is less daunting than you might think. It can be as simple as a pop of color to make a flower in a landscape stand out, or full-blown color and shading in an entire scene. The choice is yours!

Feel free to explore various materials and techniques—and even combine unexpected materials—until you find a method that you like. I often don't know if I'll add color until I start a drawing.

There are pros and cons to starting a drawing with color versus finishing with color. Personally, I always start my drawings with a graphite pencil first, even if I know that I'll color the entire thing with watercolor. Pencil is easier to erase than any coloring medium— so when you're just getting started, I recommend you always begin with pencil!

TIPS FOR ADDING COLOR

- **GO SLOWLY.** Like adding pen and ink to a drawing, once you start adding color, there's no going back! Some brands of colored pencils allow for slight erasing, but most color materials are colorfast. Make sure your drawing is ready before you commit to color. Double-check that the proportions, angles, and shapes are correct, stray pencil marks are erased, and the lines are light enough to add color on top.
- **WORK LIGHT TO DARK.** When adding color, add the lightest colors first, and work your way to the darkest. Even if you know your drawing will have a large swatch of black, work from light to dark. If you make a mistake with a lighter color, chances are you can cover it up with the darker colors as you go.

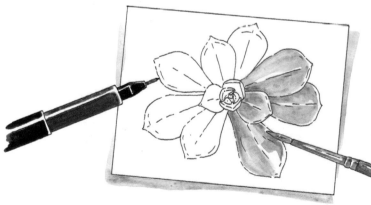

Adding color last, especially to a pen drawing, also makes your drawing look like a coloring book page. If you don't have time on-site to add color, going over your drawing with waterproof pen will allow you to add color without the ink bleeding.

When I'm traveling, I always snap a photo to use for reference later, in case I can't stay and finish coloring my drawing.

WORKING FROM LIGHT TO DARK

It's almost always best to work from light to dark when adding color. You're much more likely to be able to cover mistakes with dark color as you work if you begin with the light colors first. Working from light to dark is especially crucial when working in watercolor. Watercolors allow you to create very light layers and slowly build up the color and shadows. Don't jump straight to the darkest colors with watercolor, or you risk contaminating the lighter colors as you paint.

COLOR THEORY

When working with color, basic knowledge of color theory goes a long way. Color theory is a set of guidelines for mixing colors and combining them to make complementary combinations and color schemes.

Let's start with the very basics—primary colors! There are three primary colors: red, blue, and yellow. These are referred to as primary colors because they are the first colors, the ones that can be combined to make all other colors. When shopping for color supplies, once you have a good red, yellow, and blue (crimson red, medium yellow, and cobalt blue are my favorites), you can make nearly every color, regardless of the medium.

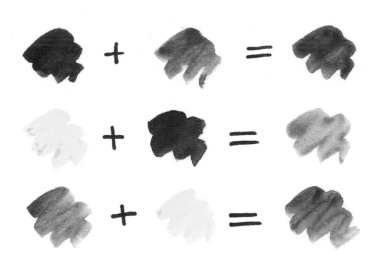

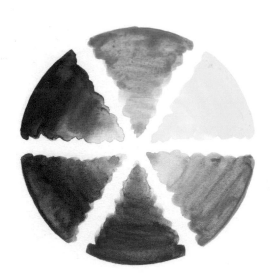

When you combine the three primary colors, you create what are called secondary colors. The three combinations are:

• Red + Blue = Purple

• Blue + Yellow = Green

• Yellow + Red = Orange

These three secondary colors can be combined with each other or with the primary colors to create tertiary (third) colors. An example of a tertiary color combination is: Red + Orange = Red-Orange.

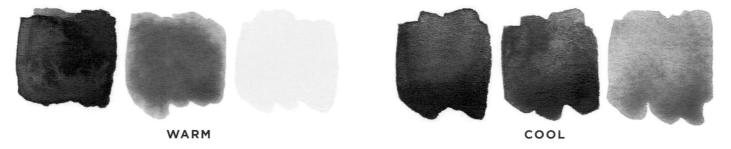

WARM **COOL**

The color wheel can be divided into two sets of colors: warm (reds, oranges, yellows) and cool (blues, greens, purples).

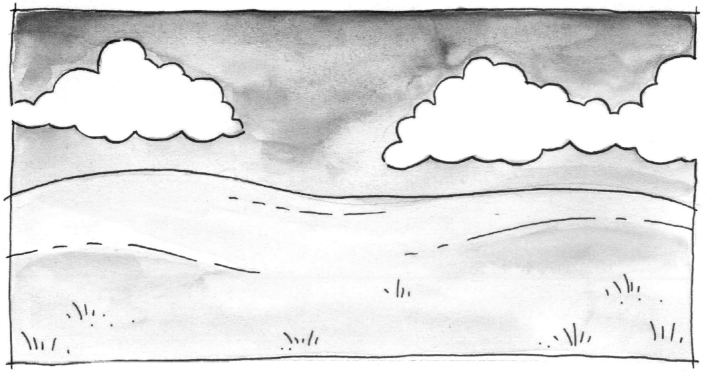

These two groups of colors can be used in a variety of ways. Cooler colors tend to appear farther away—think of the light blue sky always being just over the horizon with rolling, golden hills in the foreground. Warm colors appear closer in the foreground. For instance, adding a touch of a warm color to a still life can help the objects in the foreground appear to be closer to the viewer.

ARTIST'S TIP

Adding white to any color also gives it a bit more atmosphere and "pushes" it farther away in a scene. These tricks will come in handy more when we start drawing architecture & scenery (see pages 60–79).

COMPLEMENTARY COLORS

When you look at the color wheel, each color lies directly across from its complement. The complementary color combinations for the primary and secondary colors are: red and green, blue and orange, and yellow and purple.

Complementary colors not only complement each other, but they can also be combined to create neutral tones. When combined in equal parts, the two colors make a brownish shade that is the perfect color for adding shadows to an object painted one of those colors.

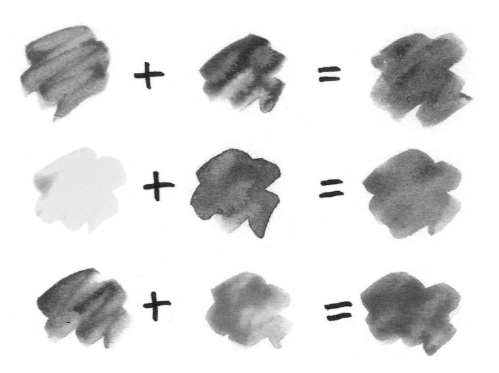

Say we have a green leaf, and we need to add a shadow to it. By combining the leaf green with some red (the complementary color to green), we can create an accurate shadow color. This murky shade of brown is a true shadow color for the green leaf.

Combining complementary colors, instead of using straight black for shadows, will make your drawings appear more realistic and colorfully accurate. In most of my own work, I use very little black. Often, the only black is the pen lines. I don't even have black in my travel watercolor set!

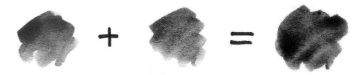

My favorite combination for shadows is dark blue with dark brown. When combined, the two colors make a dark gray shade.

This brown-blue gray can be used lightly for top marks and light shadows, or layered to imitate black. Adding a touch of this color combination can also darken any other shadow combination to really make the color "pop."

COLORED PENCIL

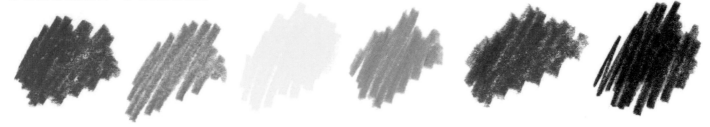

When adding color with colored pencils or watercolor pencils, start with a basic pencil drawing, making the final lines light enough to be covered by light colors.

Colored pencils are made of wax and color pigments, so they can be difficult—or impossible—to erase. Unlike their graphite cousins, the wax in colored pencils will just smear color across the page when you attempt to erase it. Make sure you're happy with the proportions, shapes, perspective, and lines before adding color.

Some of same line-making techniques you learned on pages 12–17 can also be applied with colored pencils, particularly hatching and crosshatching. If you're short on time, use quick hatch marks to indicate shadow, color, direction, and more.

These mark-making techniques can help you build up colors or shadows more slowly. The higher the quality of your colored pencils, the easier it will be to combine colors and blend them together for smooth colors and color transitions. Some colored pencil brands even come with blending pencils, which contain no pigment and allow you to blend two colors together without using another colored pencil, which could inadvertently darken the color.

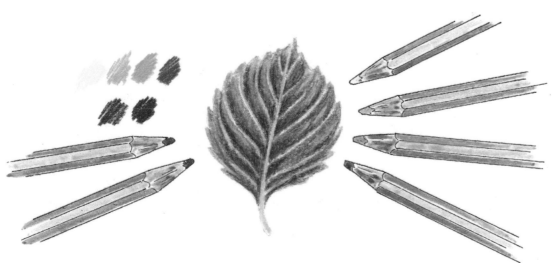

To make shadows in a colored pencil drawing, use complementary color combinations: red/green, yellow/purple, and blue/orange. Always start by adding the lighter colors first, and working your way to the darkest.

WATERCOLOR

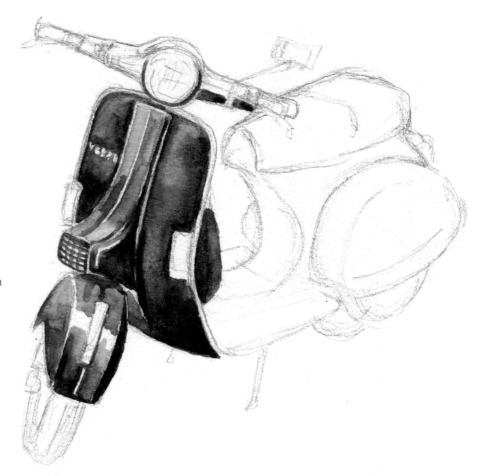

Just like adding color with colored pencils or watercolor pencils, work in graphite first! If you intend to use watercolor, it's especially important to keep your pencil marks as light as possible. Watercolor layers are mostly transparent and very thin, so you'll be able to see most pencil marks through light layers of watercolor.

When I'm done with a pencil drawing and ready to start painting, I often place my eraser flat on the paper and rub it lightly across the page to lighten the pencil marks more.

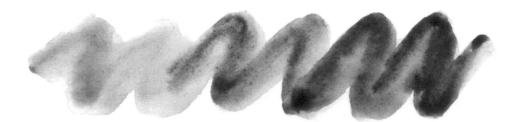

Once all your lines are ready, it's time to start building up the layers! As always, start with the lightest colors first and work your way to the darker colors.

When you add lots of water to a color, or even to the paper, it makes the color lighter and more transparent. This is a great trick, especially if you don't have white watercolor paint. If you add more color while the paint is still wet, the colors can be blended together. If you allow the paint to dry, you can add another layer on top of the dry layer.

Adding layers on top of dry paint is also a fun way to draw with your paintbrush! Hatching and crosshatching isn't just reserved for pencils and pens. Allow the paint to dry before adding final marks on top of watercolor. This allows you to create small details just like you would in a dry drawing.

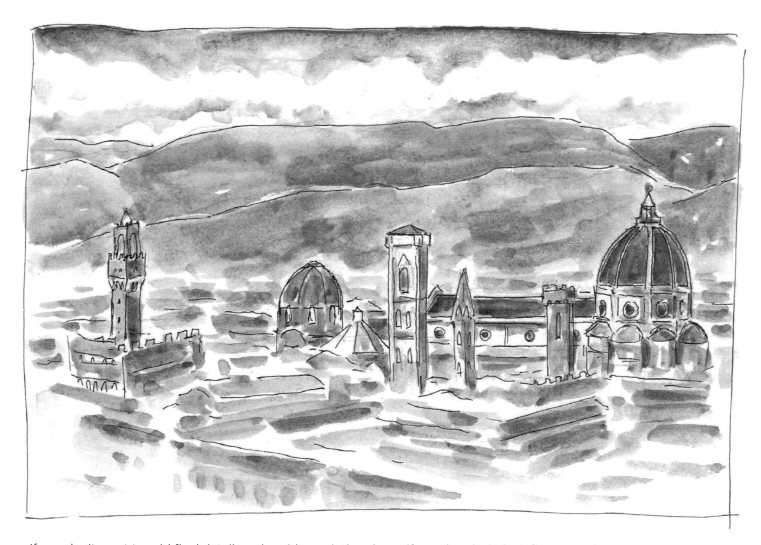

If you don't want to add final detail marks with a paintbrush—or if your brush tip isn't fine enough to make tiny details—you can also go over your dry painting with pen. Some details can't be made with a paintbrush, so this is a great option when you really want to accentuate a part of your drawing, like the outlines in this sketch of Florence.

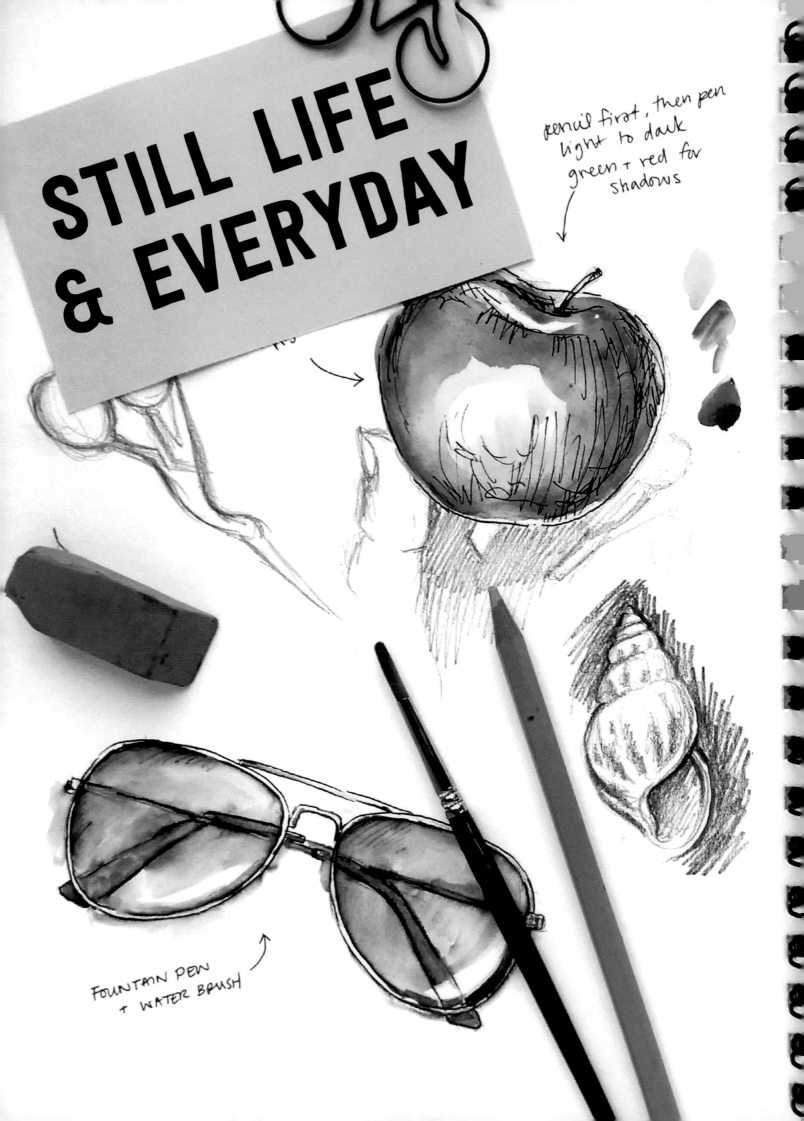

STILL LIFE & EVERYDAY

pencil first, then pen
light to dark
green + red for
shadows

FOUNTAIN PEN
+ WATER BRUSH

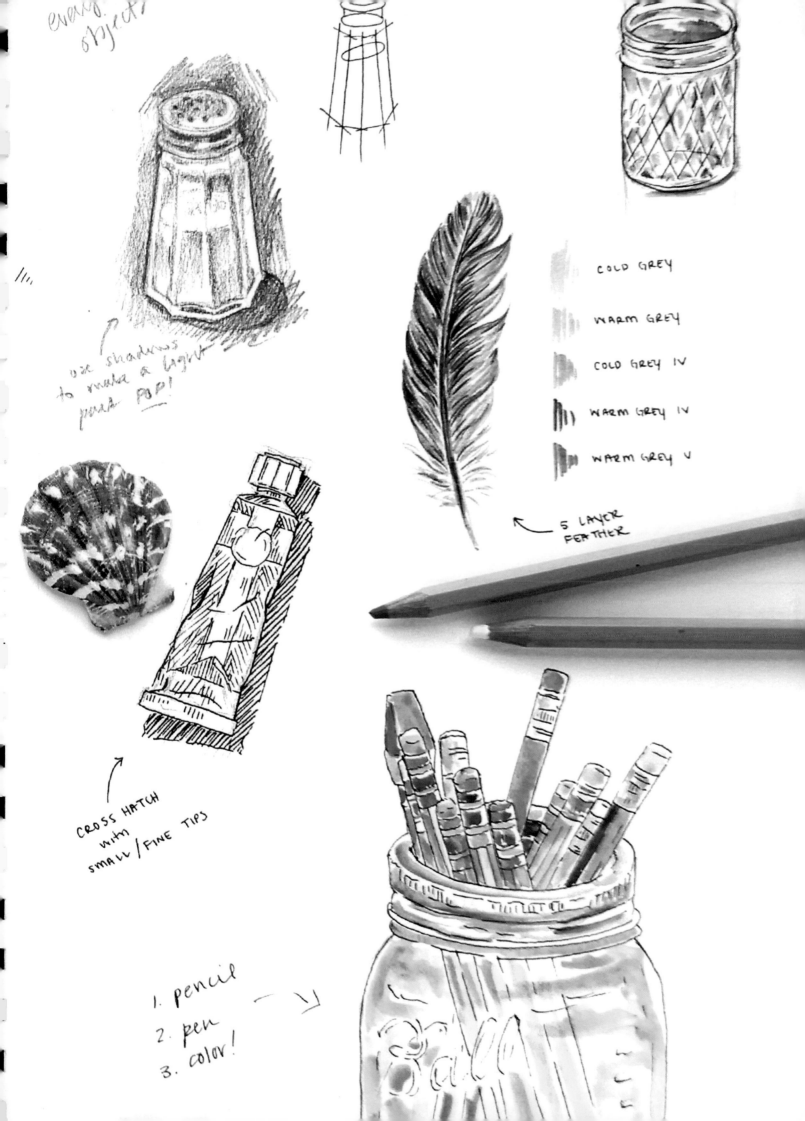

everyday
objects

use shadows
to make a light
pencil POP!

COLD GREY

WARM GREY

COLD GREY IV

WARM GREY IV

WARM GREY V

5 LAYER
FEATHER

CROSS HATCH
with
SMALL/FINE TIPS

1. pencil
2. pen
3. color!

DRAWING
THE EVERYDAY

We're lucky to be surrounded by drawing inspiration every day! Everything from the mailbox on the corner to your morning cup of coffee can be a subject for a drawing.

When practicing drawing everyday objects, it's helpful to collect drawings of similar objects or create a drawing collage of a variety of different subjects. Both are great methods for practicing and filling your sketchbook. The potted plants below are drawings I collected in my sketchbook while in Italy one summer.

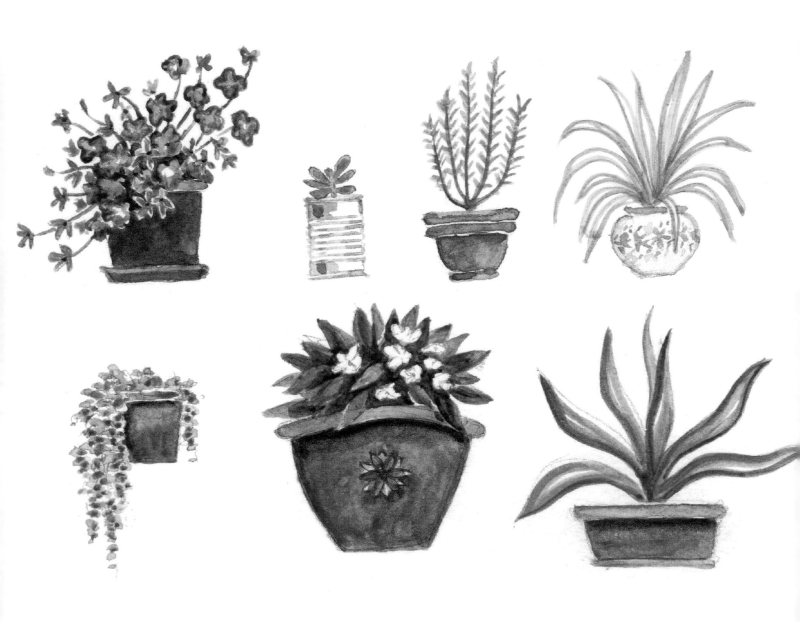

Need ideas for places to find objects for sketching? Try some of my favorite spots listed below. If you're nervous to sketch in public, ask if you can take a quick photo so you can work at home.

- **FARMERS' MARKET OR FARM STANDS:** fruits, vegetables, and flowers galore!
- **CAR SHOWS:** great for a variety of older car subjects
- **GARDEN SUPPLY STORES:** everything from succulents to lawn gnomes and plastic flamingos
- **COFFEE SHOPS:** light fixtures, coffee cups, and baked goods
- **ANTIQUE STORES:** vintage teapots and cups
- **PARKS:** bikes and playground equipment

Another great way to gather sketches is to go on a sketch crawl. Pick a day and place, and sketch your way through it. You can choose a theme or just create a new sketch at regular intervals. Sketch for one to five minutes, walk for another few minutes, and pick something in a new spot to sketch for another one to five minutes. The spontaneity can give you an eclectic collection of drawings. Make each sketch a new page, or group them all on the same page for a drawing collage.

FOOD & BEVERAGE

When drawing fruits or vegetables, pay close attention to the irregularities. Very few fruits and vegetables are perfectly round or symmetrical. Even the most perfectly round-looking orange has a divot at the top where the stem was. Make sure to really study your object and not let your mind fill in the gaps.

Food, drinks, fruits, and veggies also change depending upon the angle from which you look. Take some time to break down an object from a variety of angles—the side, bottom, looking down on it...all angles!

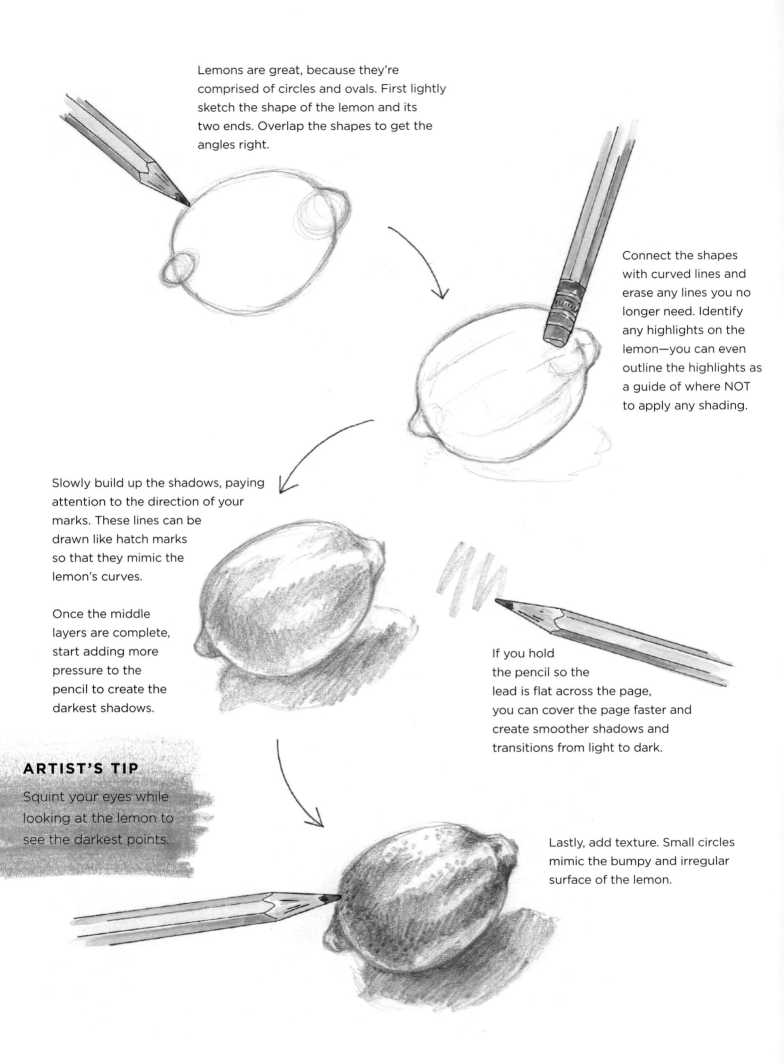

Lemons are great, because they're comprised of circles and ovals. First lightly sketch the shape of the lemon and its two ends. Overlap the shapes to get the angles right.

Connect the shapes with curved lines and erase any lines you no longer need. Identify any highlights on the lemon—you can even outline the highlights as a guide of where NOT to apply any shading.

Slowly build up the shadows, paying attention to the direction of your marks. These lines can be drawn like hatch marks so that they mimic the lemon's curves.

Once the middle layers are complete, start adding more pressure to the pencil to create the darkest shadows.

If you hold the pencil so the lead is flat across the page, you can cover the page faster and create smoother shadows and transitions from light to dark.

ARTIST'S TIP

Squint your eyes while looking at the lemon to see the darkest points.

Lastly, add texture. Small circles mimic the bumpy and irregular surface of the lemon.

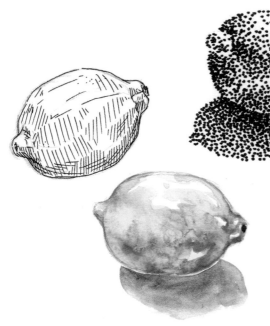

Don't be afraid to experiment with a variety of materials. Waterproof pens, permanent markers, and watercolors are all great options—and each adds their own personality to your drawings.

ARTIST'S TIP

Not seeing many natural shadows? Try arranging the objects next to a well-lit window, or shine a desk lamp on the setup to create contrast in the still life.

Once you've practiced drawing objects individually, arrange a small still life and practice drawing things in a group. Objects will overlap and cast shadows on one another in interesting ways.

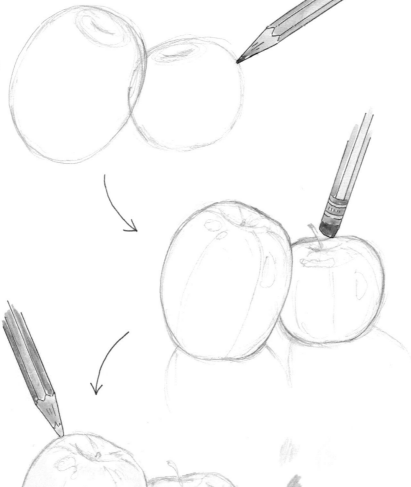

Each apple consists of an oval and lopsided circle. Don't forget the stem divot at the top.

Once the angles and sizes are correct, add any irregularities to the shapes. Is one side of the apple larger than the other? Are there curves along its base? I also add curved lines along the sides to help with shading later. Make a note of where the highlights are—there may be more than one, depending on the light source.

Begin adding colors for the lightest layers. For these apples, I applied very light layers of yellow watercolor pencil. With the pencils on their sides, you can create wider lines and curves.

Start building up the middle layers and shadows. With watercolor pencils, you can overlap the layers without worrying about blending—when you add water later, the colors will blend.

Use complementary colors as you build up the shadows. The red apple needs green to build the shadows. The green apple needs red to build the shadows. I created the shadows under the apples with my favorite shadow combination: dark brown and dark blue.

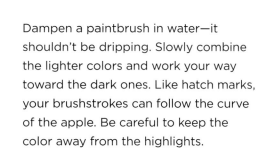

Dampen a paintbrush in water—it shouldn't be dripping. Slowly combine the lighter colors and work your way toward the dark ones. Like hatch marks, your brushstrokes can follow the curve of the apple. Be careful to keep the color away from the highlights.

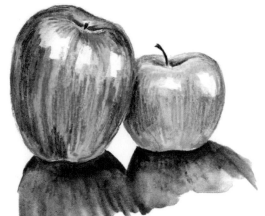

Once dry, you can go back in with pencils to add top marks, stems, and texture. Be sure the page is completely dry, so as not to rip the paper.

When drawing larger groups of fruits or vegetables, it's a good practice to do a drawing or study of an individual fruit or veggie first. One single tomato before you draw the whole flat is a great warm-up!

Sketch lightly and loosely to get the proper shape and angle of the tomato, as well as the stem, if it's visible.

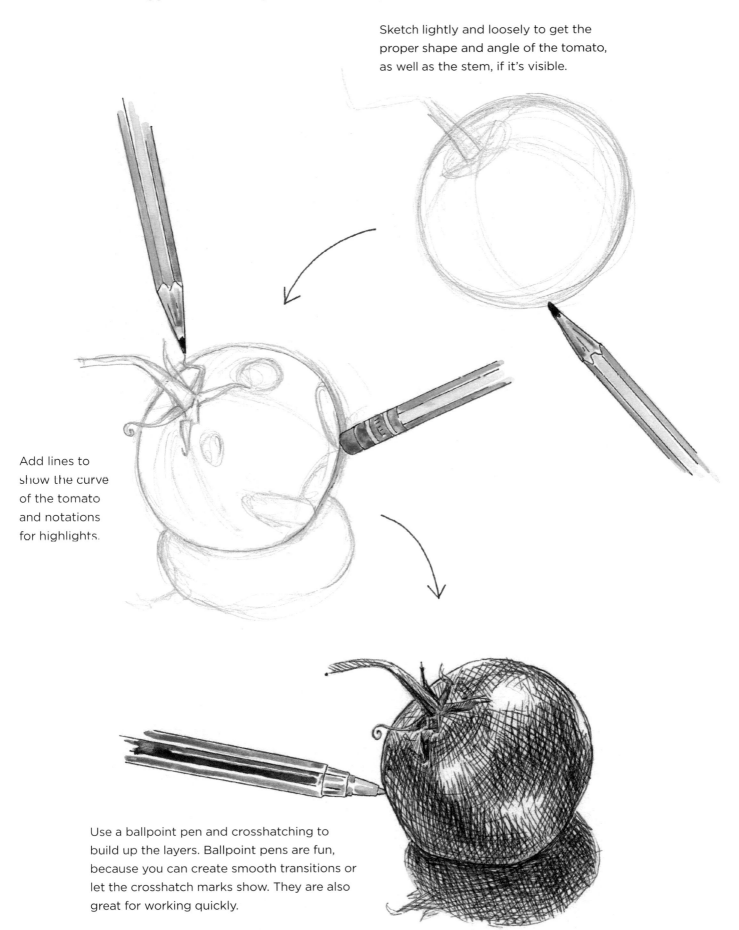

Add lines to show the curve of the tomato and notations for highlights.

Use a ballpoint pen and crosshatching to build up the layers. Ballpoint pens are fun, because you can create smooth transitions or let the crosshatch marks show. They are also great for working quickly.

Farmers' markets are great places to find lots of fruits and vegetables at once—and a wide variety! Depending on the season, you might find baskets of strawberries or crates of pumpkins.

I made this sketch while visiting Rome one summer. I sketched it in pencil first, and then quickly added watercolors and finished it up with pen to delineate the individual fruits.

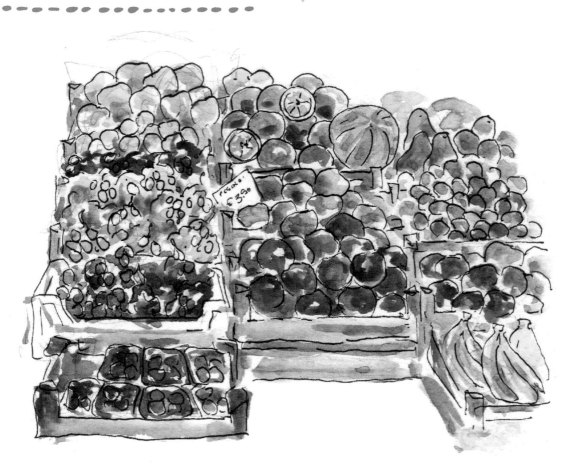

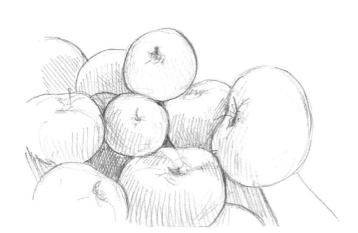

When drawing a grouping of the same object—such as a flat of tomatoes—break down each object into basic shapes with loose, overlapping lines. Be sure to draw the center of the tomato, where the stems would attach. Knowing where the center is will help with shading and showing the curvature of the tomatoes.

Once the sizes and placement are correct, use crosshatching to indicate depth, curves, and shadows. Keep an eye on the highlights, and try not to add any crosshatch or shading marks in the lightest parts. A good trick is to outline the highlight so you remember where NOT to put any ink, graphite, or color.

The same steps apply to groupings of household objects. If you have a stack of coffee mugs, break it down into basic rectangles, circles, and ovals before building up the layers and shadows.

If you're feeling bold and want to draw while you're dining out, be ready to sketch fast! Drawing while dining out is a great way to remember a particularly great meal, or pass the time if you're dining solo.

Keep your sketchbook small for these situations, so you can lean it against the edge of the table or keep it in your lap. You can sketch the objects on the table—salt and pepper shakers, silverware, candles, etc.—or wait for the main dish!

Start with the big picture first—usually the plate. Pay attention to the angle of the plate, so you get the right shape. Then work your way down to the small details—the food.

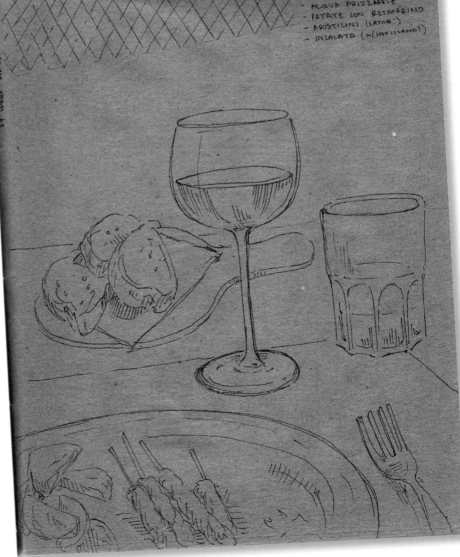

- WANDER BACK to la locanda della seconda ballena alle 18:00

SPRITZ APEROL!

CARROTE SEDANO
PANE?
ZUCCHINI
RADDICHIO? YUM!

NEW FRIENDS! ADEN! e PAOLO. ANDREA? NON SO. ma PENSO CHE HA BEVUTO 7 BIRRE. MADONNA...

1. 2. 3.

20:45
CENA SEARCH!
- CAN'T FIND (or CLOSED) CARROARMIATO
INVECE... OSTERIA SOTTORIVA!

- LASAGNE AL FORNO
- VERDURE MISTE

SPINACH
ZUCCINI

← SOLO L'ACQUA...

SO GOOD! ↑

POI... TORNO A CASA TO PACK!

MILES: 7.2 miles
17.620 steps

NON C'È MALE

This is a great situation to snap a quick photo to use for reference later, or just create a simple line drawing. When traveling, I really enjoy making quick cartoony doodles of what I ate to help me remember all the great restaurants and cafes I visited.

Drawing drinks and beverages can be fun too—everything from paper to-go cups at the coffee shop to your mug of tea at home.

Start by drawing lightly and loosely from the outside in. Get the shape of the cup first, before worrying about the liquid. Keep an eye on the thickness of the sides of the glass, which follow the same curve as the outside of the glass.

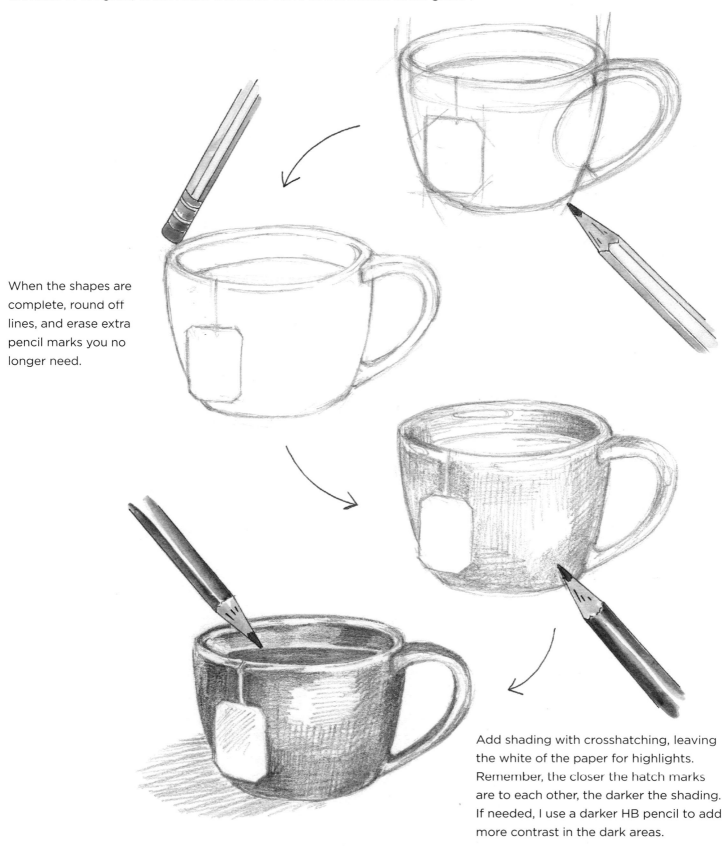

When the shapes are complete, round off lines, and erase extra pencil marks you no longer need.

Add shading with crosshatching, leaving the white of the paper for highlights. Remember, the closer the hatch marks are to each other, the darker the shading. If needed, I use a darker HB pencil to add more contrast in the dark areas.

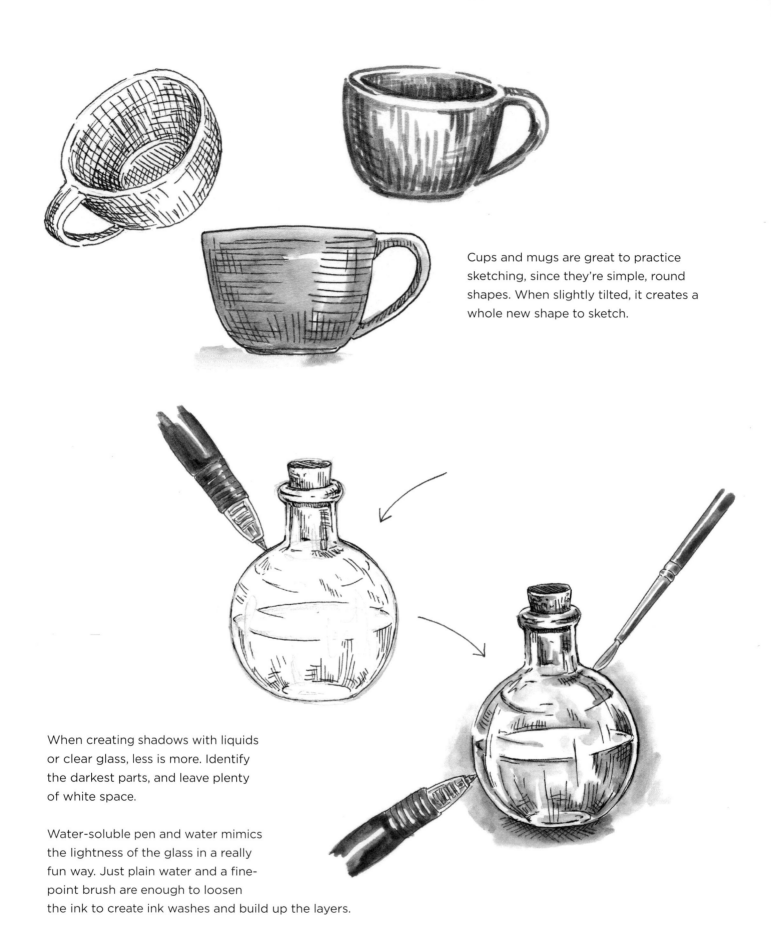

Cups and mugs are great to practice sketching, since they're simple, round shapes. When slightly tilted, it creates a whole new shape to sketch.

When creating shadows with liquids or clear glass, less is more. Identify the darkest parts, and leave plenty of white space.

Water-soluble pen and water mimics the lightness of the glass in a really fun way. Just plain water and a fine-point brush are enough to loosen the ink to create ink washes and build up the layers.

Using water along the outside of the glass to show the negative space is a great technique to show the lightness of the object.

If a part of the drawing needs to be darker, wait until the paper is dry before adding more ink or top marks.

FURNITURE

Drawing furniture can be a little tricky, since it involves so many straight lines and angles. A ruler is helpful not only to keep the lines straight, but ensure that each leg, arm, side, or angle is the right size. Even a folded piece of paper or a business card can provide a stiff, straight edge to trace along.

For chairs, stools, benches, or couches, start by drawing the shape of the seat. Most are trapezoids (four-sided shapes with only two parallel sides) or parallelograms (four-sided shapes with two pairs of parallel sides).

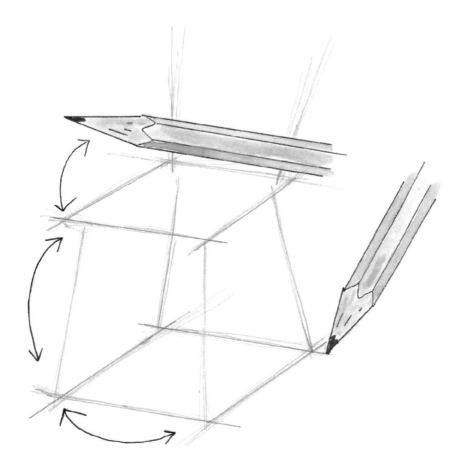

There are two parallelograms on this chair—the seat and the angle created by the ends of the legs. Use a pencil to help mark the edges of the front and back of the seat, as well as the more horizontal lines for the legs.

The spacing between the feet/legs often mirrors the shape of the seat.

Draw vertical lines to connect the seat to the ground, and lightly draw in the back of the chair.

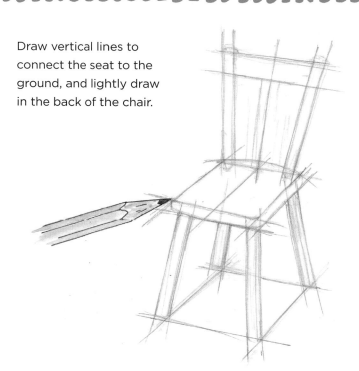

Once the length of the legs and back are right, it's time to make the chair appear more three-dimensional. This includes the sides of the seat, legs, and back of the chair.

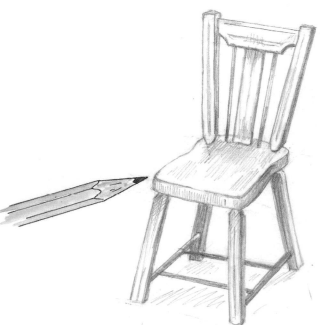

Add curves or details in the legs and seat back. Erase any of the pencil marks left from the parallelograms.

To draw stools or taller pieces of furniture, follow the same steps.
Note that a stool typically has more horizontal crossbars or footrests.

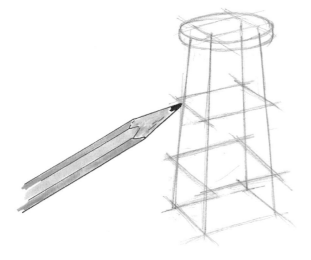

Start by drawing an ellipse, or oval, for the top of the stool. Lightly sketch the legs, paying attention to the angle formed by the ends. The parallelogram formed by the ends of the legs should match the shape that the crossbars form on the legs.

Start making the stool more three-dimensional. The angles of the sides of the legs continue along the lines of the bottom parallelogram. In the diagram to the right of the stool, the dots indicate where the bottom of the legs fall.

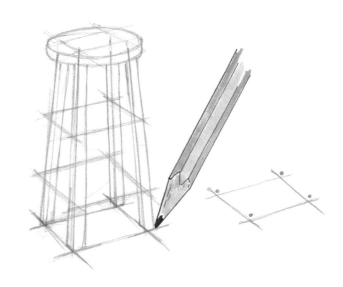

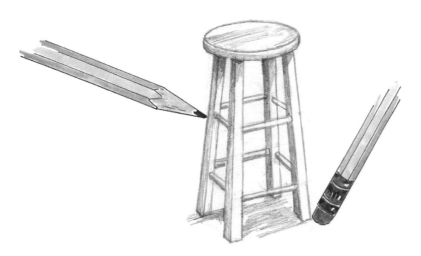

Add shading. The inside of the legs is darker, since they catch less light. Use hatch marks to create woodgrain-like texture.

BICYCLES

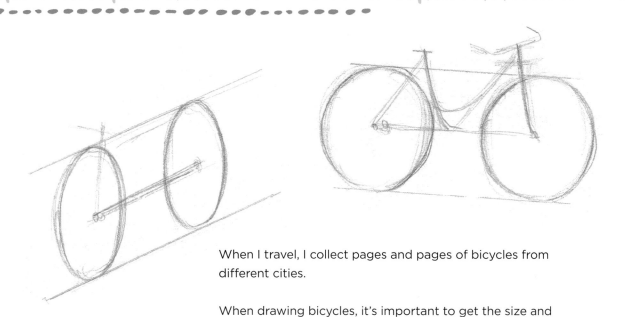

When I travel, I collect pages and pages of bicycles from different cities.

When drawing bicycles, it's important to get the size and angle of the wheels correct. While the angle may change, the size of the two wheels is almost always the same.

Draw a line for the top of the wheels, using a straight edge or ruler if needed. Draw the rear wheel so the top just touches the line. Draw a line that just touches the bottom of the wheel. Then draw the second wheel between the two lines.

Draw a line connecting the centers of both wheels. Just above that, draw a horizontal bar for the bike's top tube.

Add lines to frame out the rest of the bike's tubing, and sketch in the chain or chain cover.

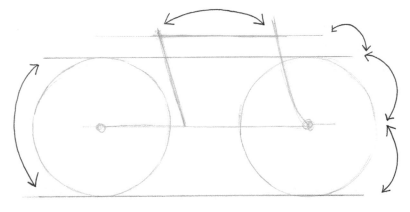

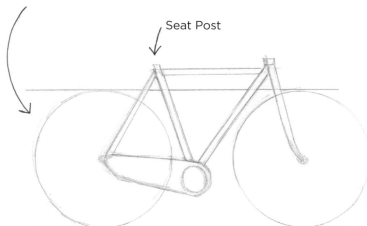

Seat Post

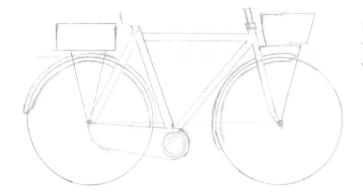

Lightly sketch the front and rear wheel covers or fenders, which follow the curves of the wheels. If your bike has baskets, draw the straight lines up to the baskets above the fenders.

Lightly sketch the seat and handlebars, as well as the pedal or crank arm, hub on the wheels, and any spokes.

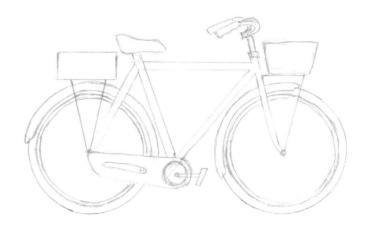

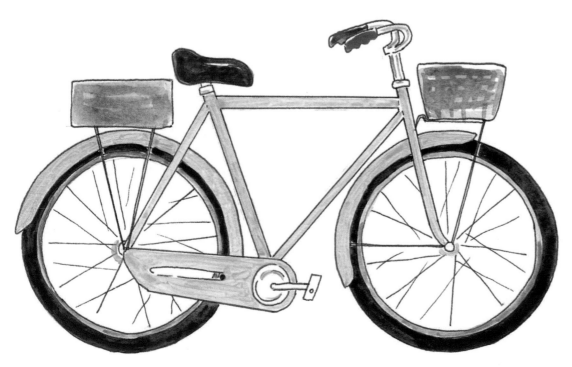

Outline the bike with a fine-point, waterproof pen. When the ink is dry, erase any visible pencil marks or smudges before you add color. Use a small brush with a fine point to add watercolor paint.

EXPLORING OTHER EVERYDAY OBJECTS

Drawing random objects around the house, office, coffee shop, and more may seem like an odd choice, but the more you draw from observation, the more you build your drawing vocabulary. Drawing from life will help make your drawings from the imagination more realistic, because they are informed from life.

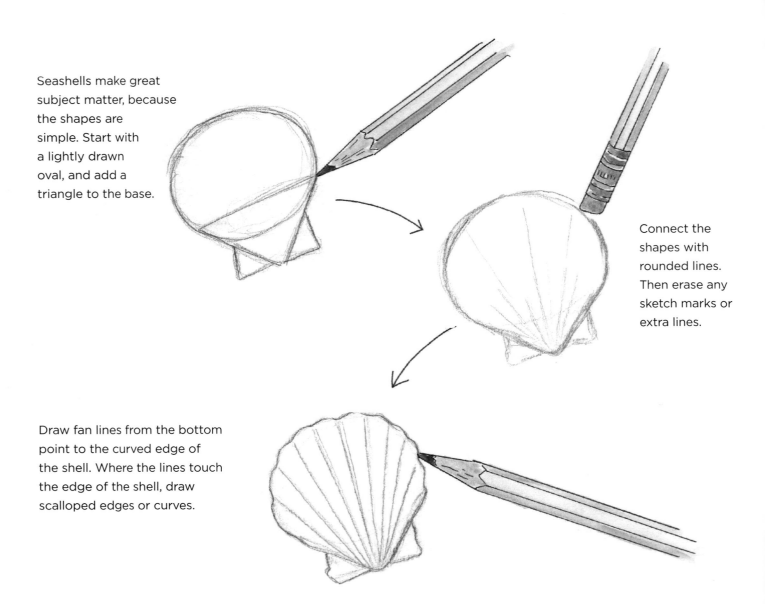

Seashells make great subject matter, because the shapes are simple. Start with a lightly drawn oval, and add a triangle to the base.

Connect the shapes with rounded lines. Then erase any sketch marks or extra lines.

Draw fan lines from the bottom point to the curved edge of the shell. Where the lines touch the edge of the shell, draw scalloped edges or curves.

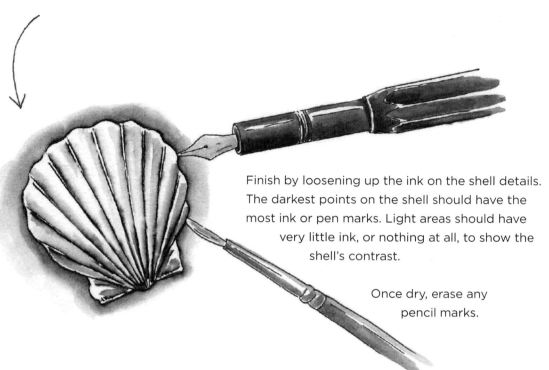

Now add shading! I used a fountain pen. First outline the shell, and then draw thin, light lines for details inside the shell. With a water brush or a regular brush dipped in water, loosen up the ink on the outside of the shell. Just touching your brush to the ink will make it start to bleed across the paper, so you can spread it like an ink wash.

Finish by loosening up the ink on the shell details. The darkest points on the shell should have the most ink or pen marks. Light areas should have very little ink, or nothing at all, to show the shell's contrast.

Once dry, erase any pencil marks.

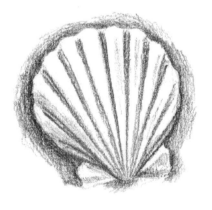

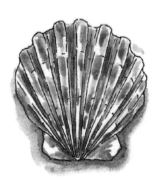

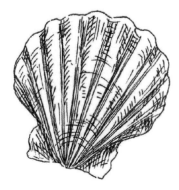

Seashells are particularly fun, because you can color or draw them in all sorts of media— everything from regular pencil and watercolors to pen and colored pencils!

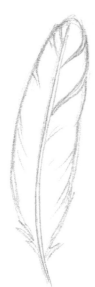

Even the smallest things in nature can make for a fun drawing. Feathers are particularly fun—and they come in so many shapes and sizes! Start with a light outline. Pay attention to the curve and the shaft in the center. Some feathers are wider on one side than the other, rather than symmetrical, so be sure to really study the feather you're drawing.

Lightly sketch any breaks along the sides of the feather, curving them down toward the feather's center.

With a water-soluble pen or fountain pen, make loose marks on the sides of the feather, along the center, and all over the inside.

With a brush and water or water brush, loosen up the pen marks. Keep any highlights free of ink and wash for contrast.

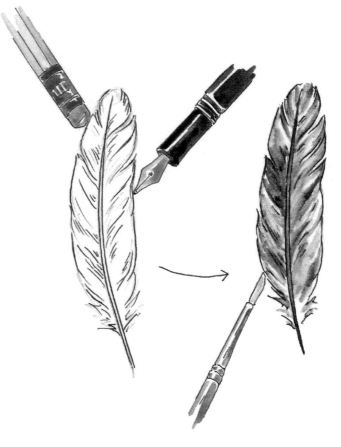

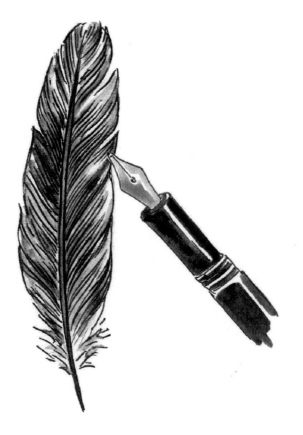

When the feather is dry, use pen to add top marks and details. You can also use pen to make the darkest shadows even darker so they "pop" more off the page. Curve the lines with the feather to add more realistic texture. When it's complete and dry, erase any remaining pencil marks.

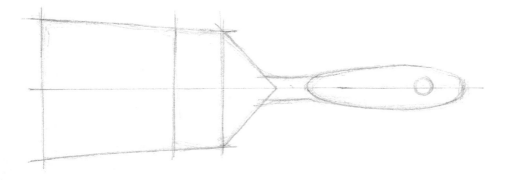

This paintbrush may seem complex, but it's just a handful of simple shapes! Start by drawing a light line across the page to help you keep the proportions in check and act as a guide to ensure each side is equal.

The bristles may look like a rectangle at first glance, but the top and bottom sides slightly bow out from the center.

Connect the shapes of the handle with a curved line. Start adding details to the brush: bristles, shapes in the wood, and details in the metal.

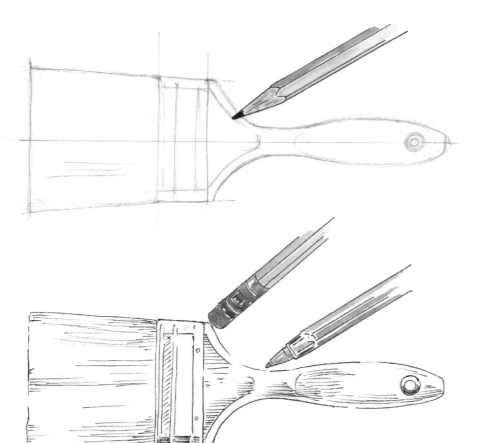

With a ballpoint pen, build up the darker parts of the brush. Keep any highlights free of marks. In the wooden handle, the pen marks create woodgrain texture. You can use similar marks to create individual brush hairs in the bristles. Then erase any pencil marks.

Keep adding more and more layers of hatch marks throughout—especially in the bristles. Curve the pen marks with the sides of the handle to make it more three-dimensional.

These Italian-style coffee percolators provide an extra challenge, since they have so many facets. When drawing very angular objects like this, don't hesitate to use a ruler or folded piece of paper to achieve straight edges.

Start with a long, vertical line for the center of the pot. The top and bottom halves of the coffee pot are trapezoid shapes that almost mirror each other.

From this angle, the top and bottom of the pot are long ovals. Even if you can't actually see the whole curve of the base, draw the whole oval to make the side and curve more accurate. Break down the handle into shapes as well.

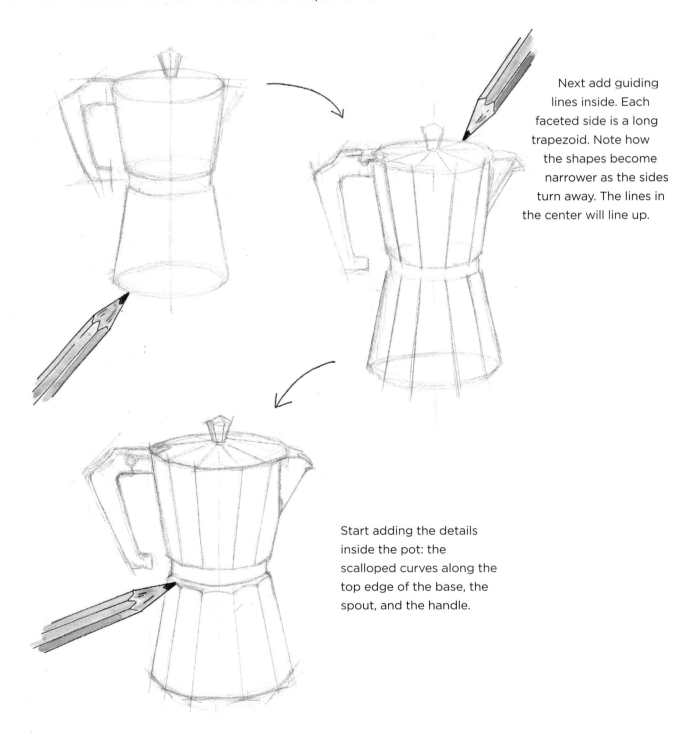

Next add guiding lines inside. Each faceted side is a long trapezoid. Note how the shapes become narrower as the sides turn away. The lines in the center will line up.

Start adding the details inside the pot: the scalloped curves along the top edge of the base, the spout, and the handle.

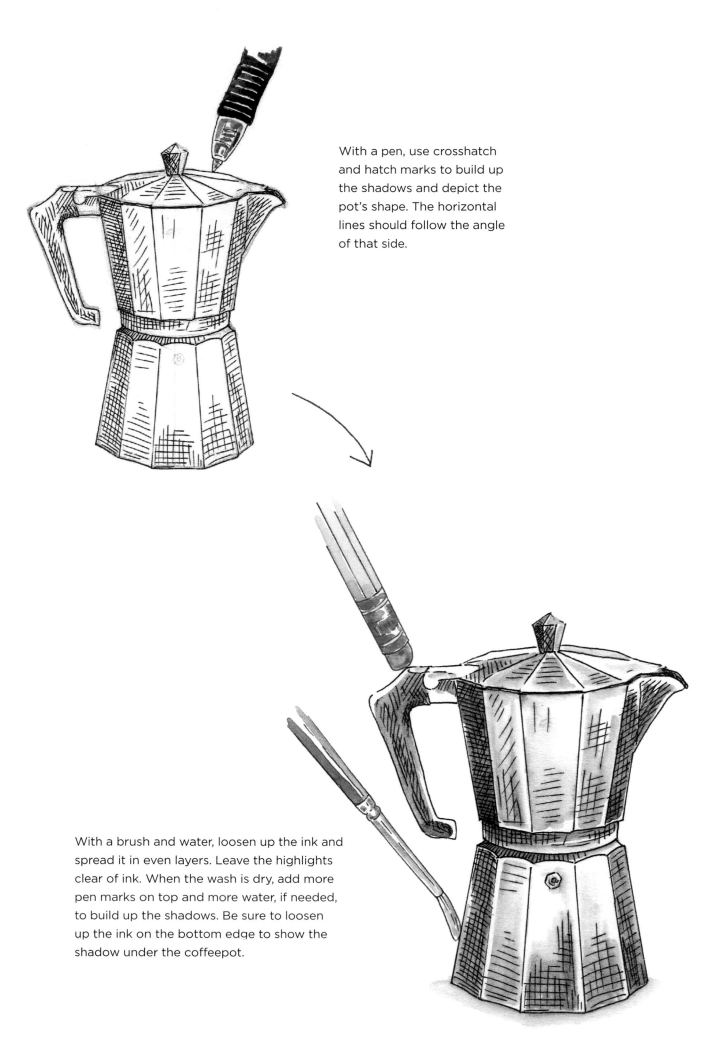

With a pen, use crosshatch and hatch marks to build up the shadows and depict the pot's shape. The horizontal lines should follow the angle of that side.

With a brush and water, loosen up the ink and spread it in even layers. Leave the highlights clear of ink. When the wash is dry, add more pen marks on top and more water, if needed, to build up the shadows. Be sure to loosen up the ink on the bottom edge to show the shadow under the coffeepot.

Everyday objects can be drawn in so many ways. Combining materials and techniques gives your work and sketchbook fun variation. As much as I like creating completely shaded and realistic drawings, I also love having simpler sketches in my sketchbooks.

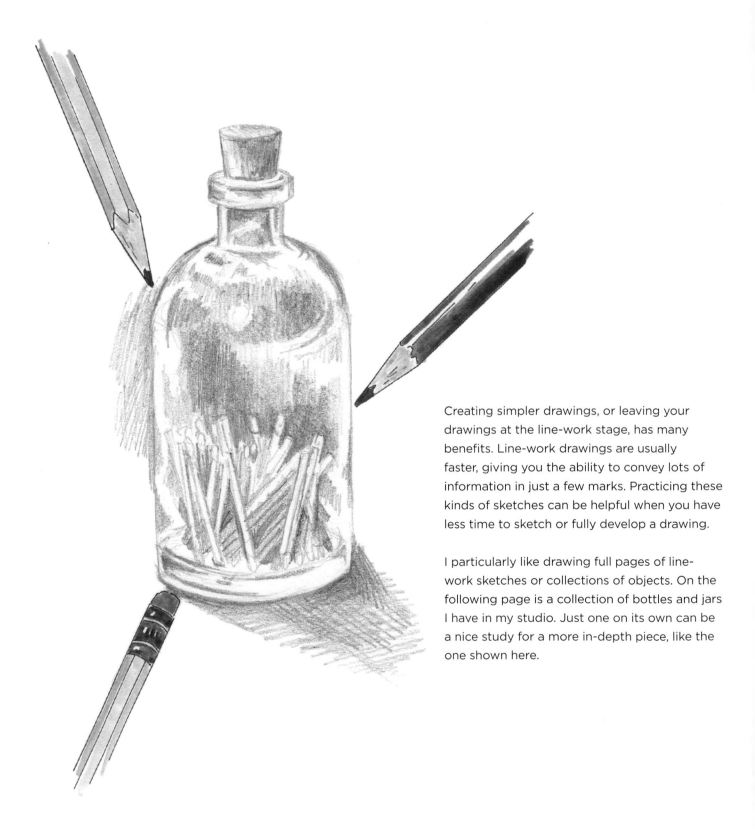

Creating simpler drawings, or leaving your drawings at the line-work stage, has many benefits. Line-work drawings are usually faster, giving you the ability to convey lots of information in just a few marks. Practicing these kinds of sketches can be helpful when you have less time to sketch or fully develop a drawing.

I particularly like drawing full pages of line-work sketches or collections of objects. On the following page is a collection of bottles and jars I have in my studio. Just one on its own can be a nice study for a more in-depth piece, like the one shown here.

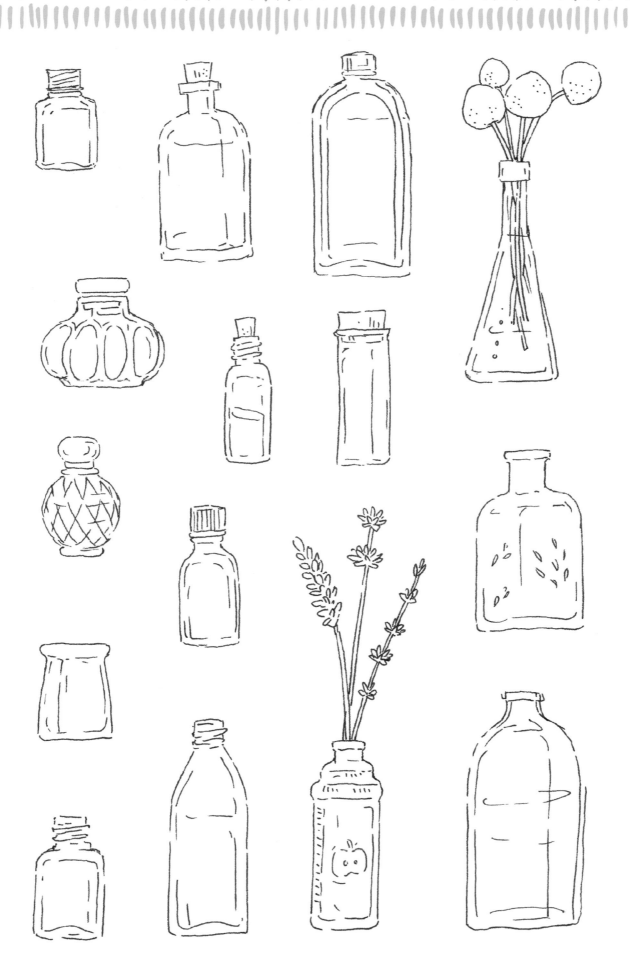

Drawing collections is one of my favorite ways to fill my sketchbook when traveling. Old pharmacies or apothecaries, candy or gelato shops, and other stores have myriad similar objects in one place, making it easy to gather a full page of drawings.

This page is from an old pharmacy in Florence, Italy, which was filled with vintage vials and bottles full of minerals, herbs, and spices.

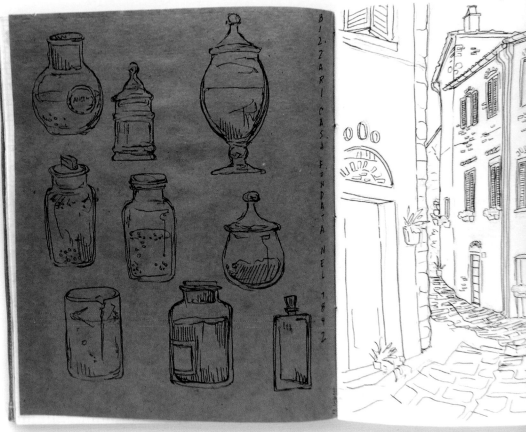

These types of drawings can also make a type of diary. For a travelogue, personal diary, or just doodles in your planner, simple line-work art is fun and adds variety to your work. They don't have to be perfect—and they tend to convey more personality.

Even if there's nothing in sight to draw, you can always draw from what you personally know...literally! The sketches on the following page are from my 2016 trip through Italy, when I went with a small carry-on suitcase for a month and a half away. I had a long train ride and had already sketched my surroundings, so I tried to sketch the contents of my suitcase from memory. It was a fun way to pass the time.

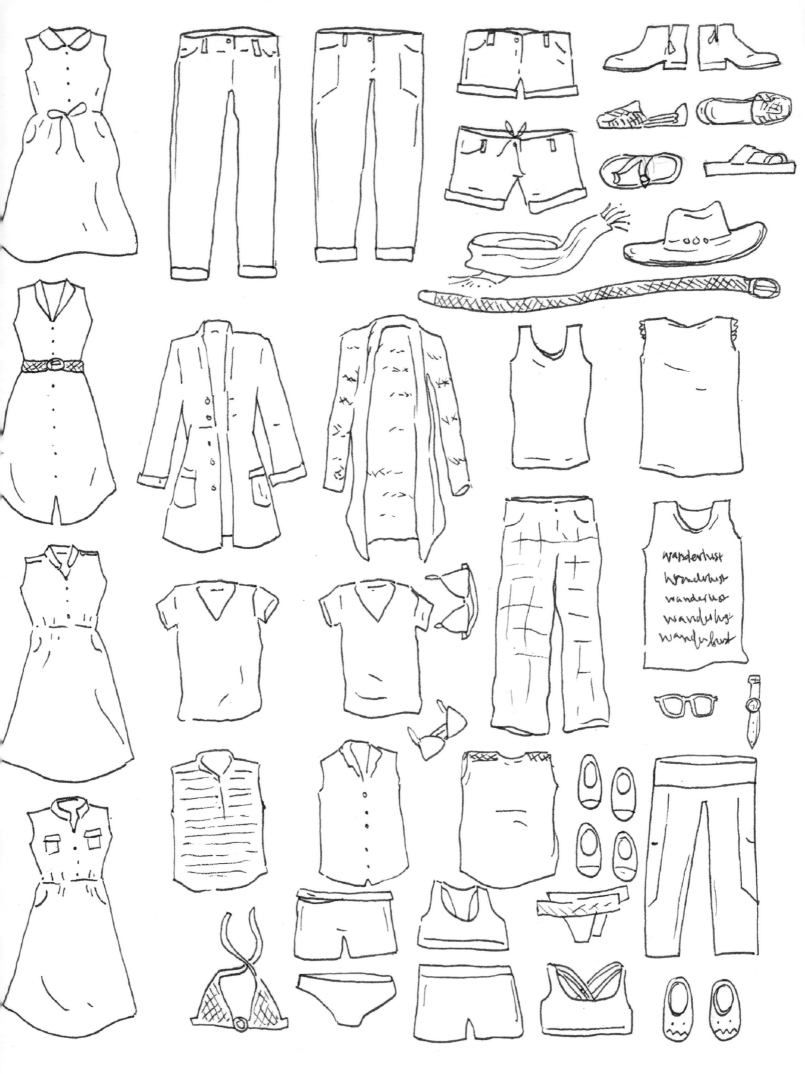

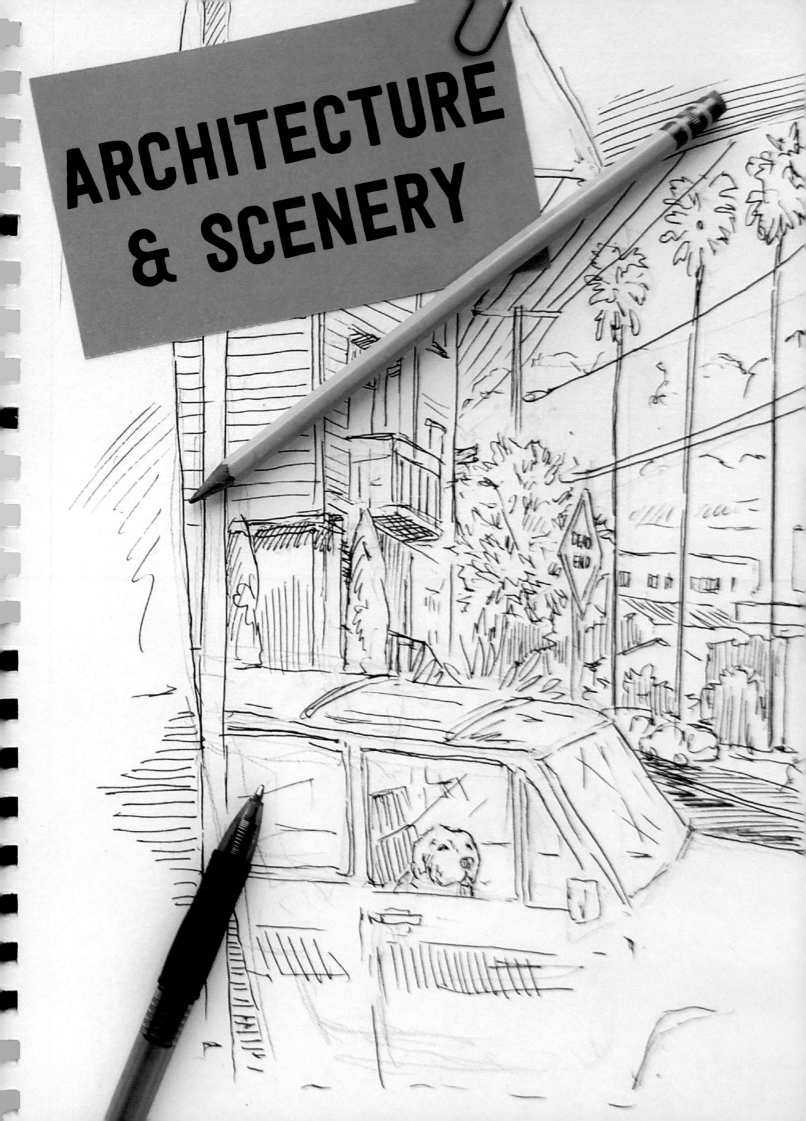

THE BASICS

One of the great things about drawing architecture and scenery is that we are fully surrounded by it! Our own homes, the local coffee shop, old neighborhoods, airports, restaurants, cities, and more can all be drawing inspiration.

I could spend all day drawing buildings and streets—especially after traveling through Europe. The streets just feel more charming and whimsical, with their wooden shutters, cobblestone streets, and stone facades.

Even if you can't escape to Europe or some foreign place, you can still find bits of whimsy and plenty of intrigue on your very own streets.

Before we dive into how to draw buildings, let's go over the basics in framing, point of view, and perspective, all of which will help you draw architecture, landscapes, and scenery.

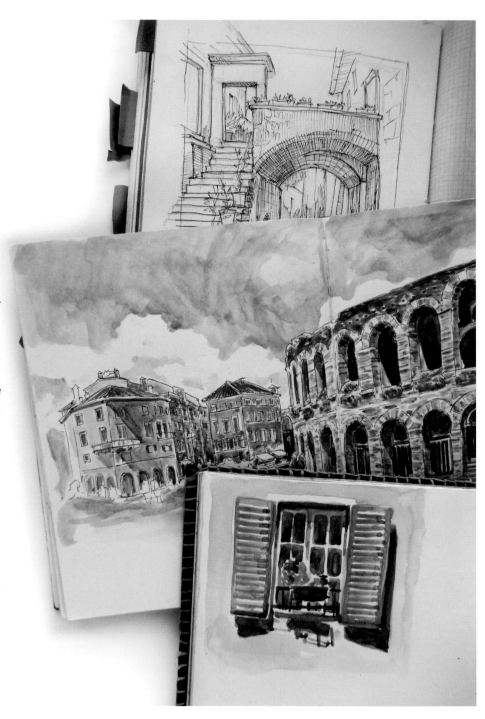

FRAMING

There are several ways you can frame, or plan out, an architectural drawing. Each method has its benefits, and some are more suited for certain scenes and scenarios. There are many additional ways to frame your drawing, but the following are the three I personally use most often.

BLEED DRAWING

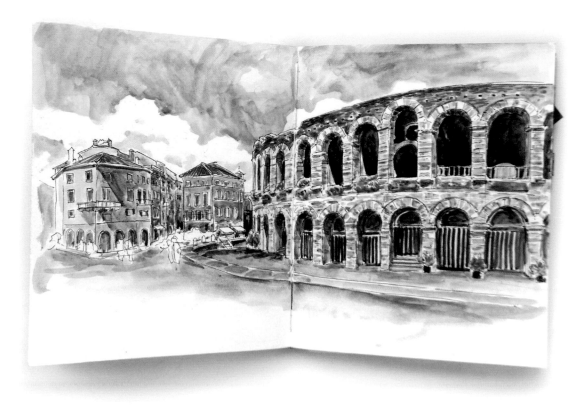

With this method, the drawing goes all the way to the edges of the paper, not leaving any sort of frame around the artwork at all. I often make a bleed drawing when I'm sketching a large landscape or building, especially when the scene is large enough to spread across and fill two pages. The larger the drawing, the more space you'll have for adding details.

A bleed drawing is perfect for epic landscapes—think the Grand Canyon, ocean vistas, mountains, and any scene in which it seems impossible to contain or document the whole thing. Pushing a landscape all the way to the page's edge helps convey how grand and large the real-life scene is.

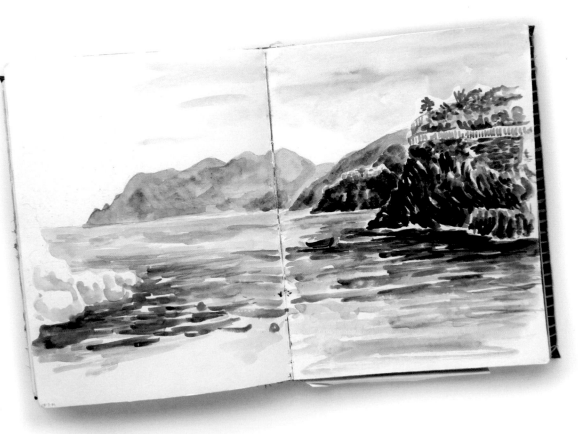

FLOATING

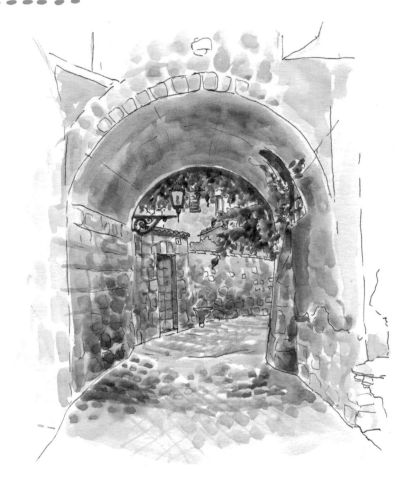

Sometimes you run out of time, or you may want to accentuate a particular part of a scene. By leaving the edges unfinished around the central focal point, you'll draw the viewer in, while naturally framing your drawing with the blank paper around it. I love to have architectural details floating in the center of the page.

Floating frames are handy when you're collecting building details. Windows, doors, flower boxes, building numbers, street signs— all these types of items, when gathered on pages in collections, look really lovely in floating frames.

FRAMED

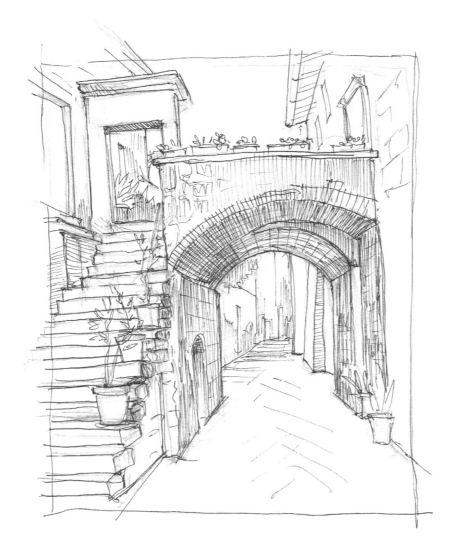

A framed drawing is just like it sounds—framed! A quick square, rectangle, or even circular frame around the drawing allows you to simplify a tricky scene from the get-go. It can also be used like a floating frame to accentuate or bring focus to a part of the drawing. By honing in on what drew your eye to the scene initially, you're less likely to get caught up in all the details outside of the frame.

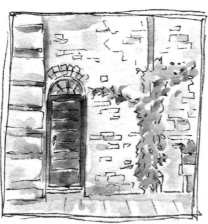
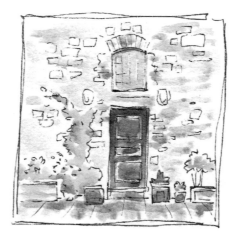
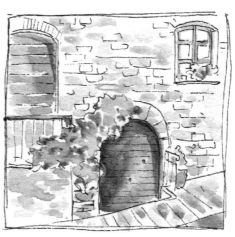

Framed drawings can be large, like the size of your page, or very small. I like to create small framed drawings for quick studies, often grouping multiples on the same page. Sometimes these quick framed studies turn into larger drawings or paintings later, but I also just really like how they look grouped together on a page.

You can also use frames to emphasize the size or shape of a scene. Tall buildings and trees or narrow streets feel taller and narrower in a small drawing when the scene is framed with a long, narrow rectangle.

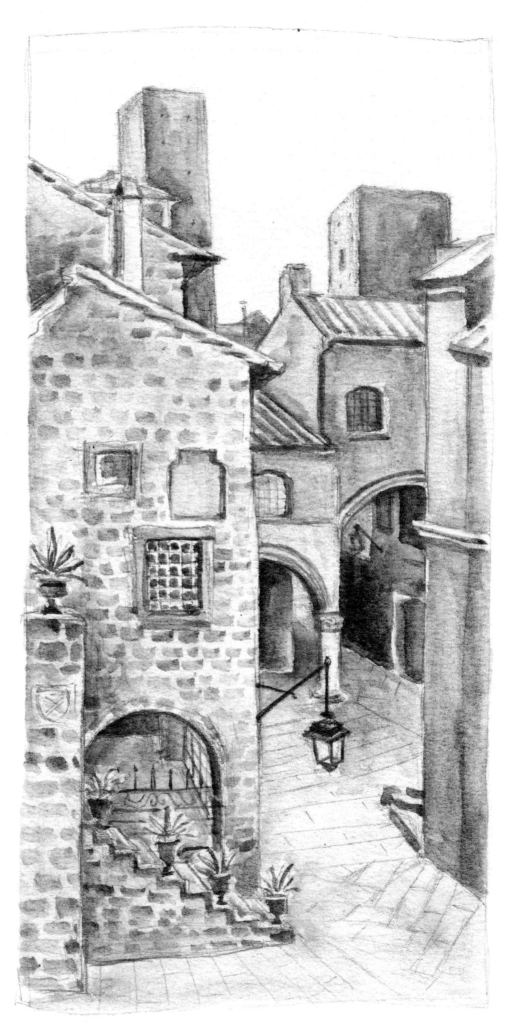

POINT OF VIEW

A scene's point of view determines a lot about your drawing, even before you put pencil to the page.

FLAT

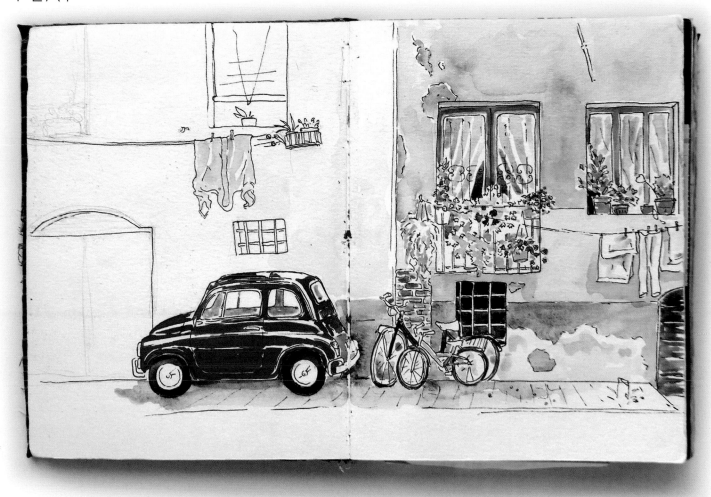

For a flat view, you are positioned directly in front of your scene, if not completely perpendicular to it. With a flat view, you eliminate the need to worry about perspective.

PERSPECTIVE

Perspective refers to when you can see your scene receding into the distance. Scenes involving perspective can be trickier to draw, but they appear more three-dimensional when drawn correctly. We'll talk more about perspective on pages 69–70.

OVERHEAD

An overhead, or bird's-eye view, occurs when you're looking down on the scene. I don't come across many opportunities to draw an overhead view of a scene, but they're hard to resist when you find a fun one! They typically involve a lot of perspective work, so be ready to sketch in pencil before inking any of the lines.

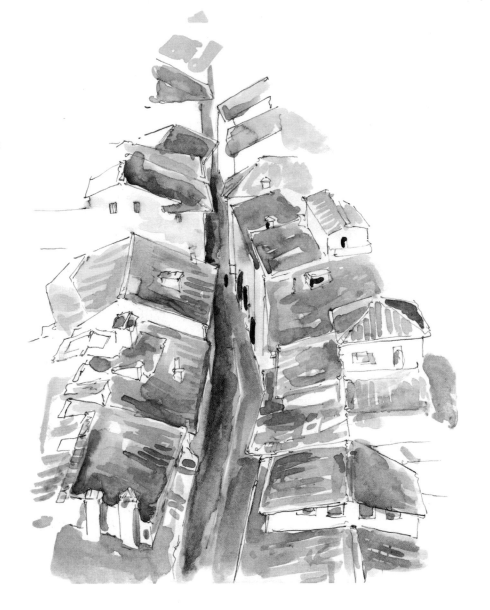

SILHOUETTE

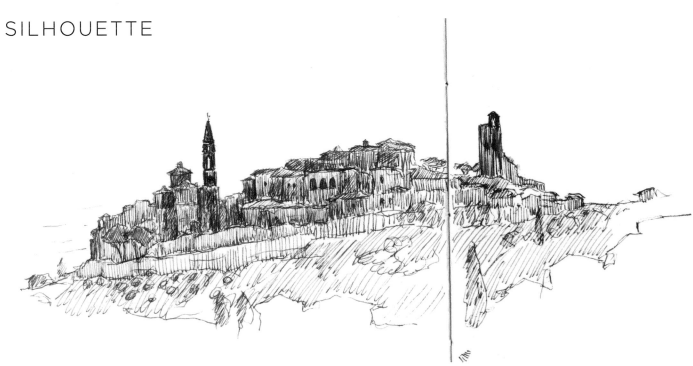

When drawing cityscapes, or even landscapes from afar, if the light is just right it creates a silhouette. Sometimes you can make out individual trees or buildings, but if the light behind the scene is bright enough, you'll see only the shadow or outline.

PERSPECTIVE

The backbone to any accurately drawn building is perspective. Proper perspective in a drawing conveys something as three-dimensional. It also acts as a guide for ensuring you get all the proportions correct.

Imagine you are standing in the middle of a street, looking down the road. As objects recede into the distance and are farther away, they look smaller. As they get closer to you, they look larger. Most of these objects follow lines of perspective that will help you draw their changes in size more accurately. There are a few kinds of perspective, and each one is progressively more complex; the more points of view or angles you add to your scene, the more challenging it is to draw.

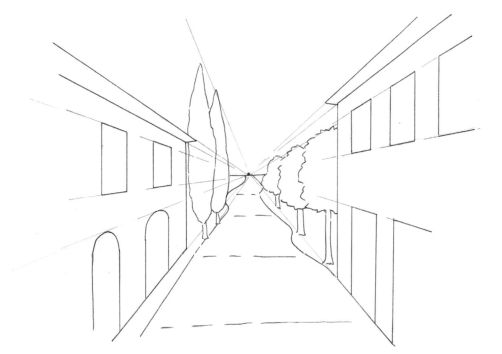

ONE-POINT PERSPECTIVE
The simplest is one-point perspective, which means everything recedes to one point in the distance along the horizon line, which is most often at eye level to the viewer. Standing on a street and looking straight down the road is one-point perspective. Trees, fence posts, telephone poles, doors, and windows on buildings all become smaller as they move farther away from you.

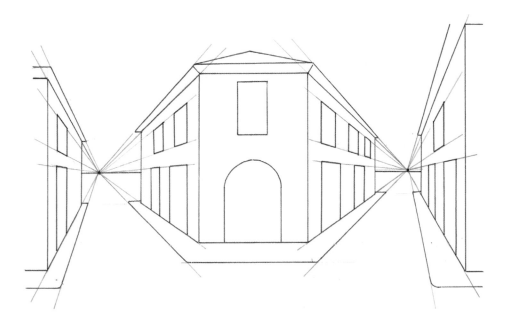

TWO-POINT PERSPECTIVE
If we change our point of view to standing on the corner of two streets, we have two-point perspective, because there are two different roads disappearing into the distance.

THREE-POINT PERSPECTIVE The more views you add to a scene, the more complex. If you shifted your view upward while standing on this street corner, you'd now see objects receding into the distance to the left, right, and above you. A bird's-eye view scene also involves three-point perspective, since the buildings move away from you, toward you, and down to the ground.

Once you practice drawing perspective, you'll be able to convey even the most complicated of views and make them appear more three-dimensional. Just make sure to sketch slowly and lightly. A ruler can come in handy when working with a tricky perspective and to make sure the lines of perspective are straight.

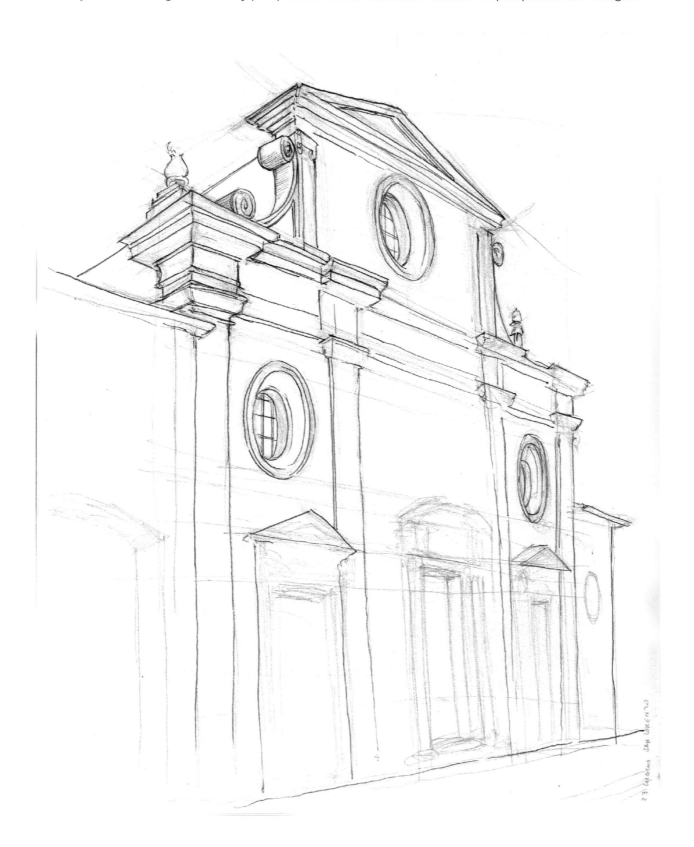

DRAWING
ARCHITECTURE

When starting an architectural drawing, there are a few things to consider:

- **TIME:** Will you have time to complete the whole drawing, or just do a study? Will the light shift before you finish?

- **FRAMING:** Is this a large scene that can take up the whole page? Or do you want to focus on one portion of the scene?

- **POINT OF VIEW:** Is there perspective involved? Or do you have a flat view of the scene?

- **MEDIUM:** Besides starting with pencil, will you be adding color on-site? Or will you do ink work and add color later?

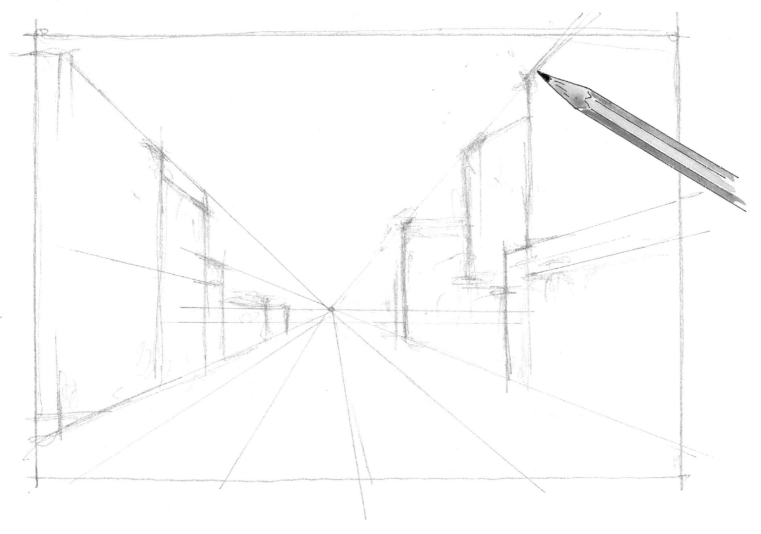

Once you're ready and your scene is selected, it's time to get started! When drawing a busy one-point perspective scene, I usually start with a quick frame to simplify things. Lightly sketch in a frame and the horizon line.

Very loosely sketch where the buildings are, and use a ruler to double-check that they follow the lines of perspective.

Once the buildings and guidelines are in place, start adding more details to the buildings. The windows and doors should all follow the perspective guidelines.

Start adding more details to the entire scene: trees, eaves on the windows or doors, and any signs or details on the buildings.

Once all the details are sketched out, grab a pen and go over the lines. Take your time, especially when outlining small details.

Start building up the shadows with hatch marks and crosshatch marks. The direction of your lines can be used to show the perspective of the scene as well. Don't feel like you need to draw every single brick or crack along the walls. You can simplify the scene as much as you want! If there is a specific focal point that you want the viewer to focus on, add the most detail to this point to draw attention. When the pen is dry, erase any visible pencil marks.

DRAWING
LANDSCAPES

Landscapes follow a similar set of steps as architectural scenes, but they can be looser. Landscapes are natural and organic, so your mark-making can follow suit!

For this landscape, I'm going to create a floating frame. The mountains in the distance are naturally framed by two foreground oak trees, so I don't want to box them in. When drawing a scene with mountains and rolling hills, there likely aren't many perspective lines to follow—the key is to keep the proportions of the mountains and hills relative to one another.

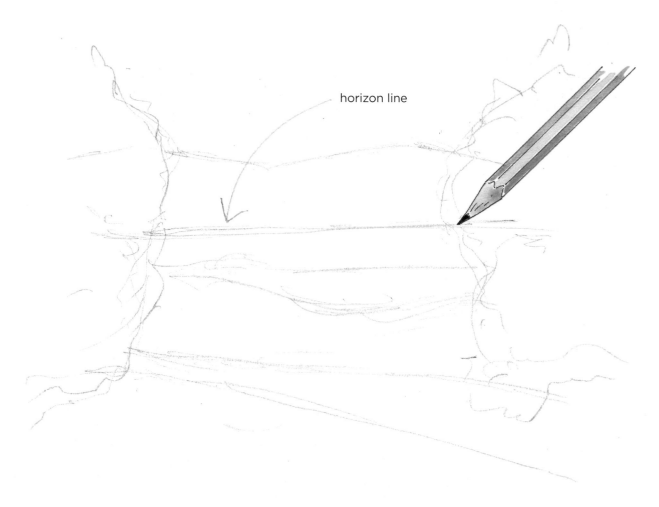

horizon line

Sketch in the horizon line where the land meets the base of the mountains, and lightly sketch in the mountain range. From the base of the mountains, sketch each hill in order as they approach the bottom of the page. These lines can be loose and sketchy, overlapping with the lines for the trees along the right and left sides.

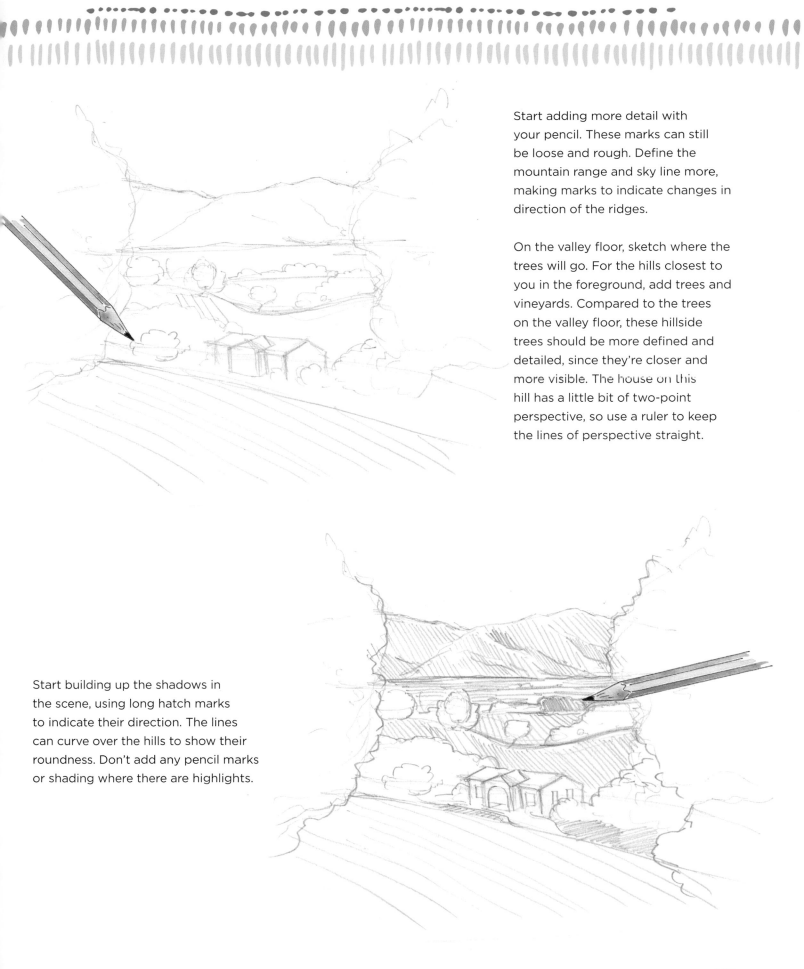

Start adding more detail with your pencil. These marks can still be loose and rough. Define the mountain range and sky line more, making marks to indicate changes in direction of the ridges.

On the valley floor, sketch where the trees will go. For the hills closest to you in the foreground, add trees and vineyards. Compared to the trees on the valley floor, these hillside trees should be more defined and detailed, since they're closer and more visible. The house on this hill has a little bit of two-point perspective, so use a ruler to keep the lines of perspective straight.

Start building up the shadows in the scene, using long hatch marks to indicate their direction. The lines can curve over the hills to show their roundness. Don't add any pencil marks or shading where there are highlights.

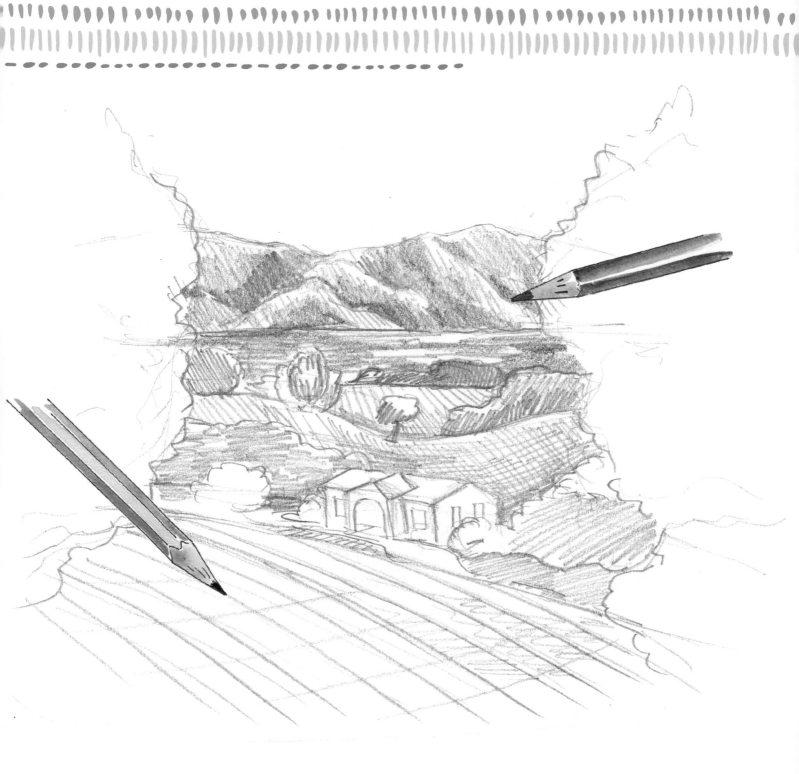

At this point, I've made the darkest shadows possible with a regular pencil. To get the shadows darker, you can use a softer lead pencil—anything from a 4B to an 8B is great. With your pencil on its side, you can smooth out the shadows so they're soft and gradual.

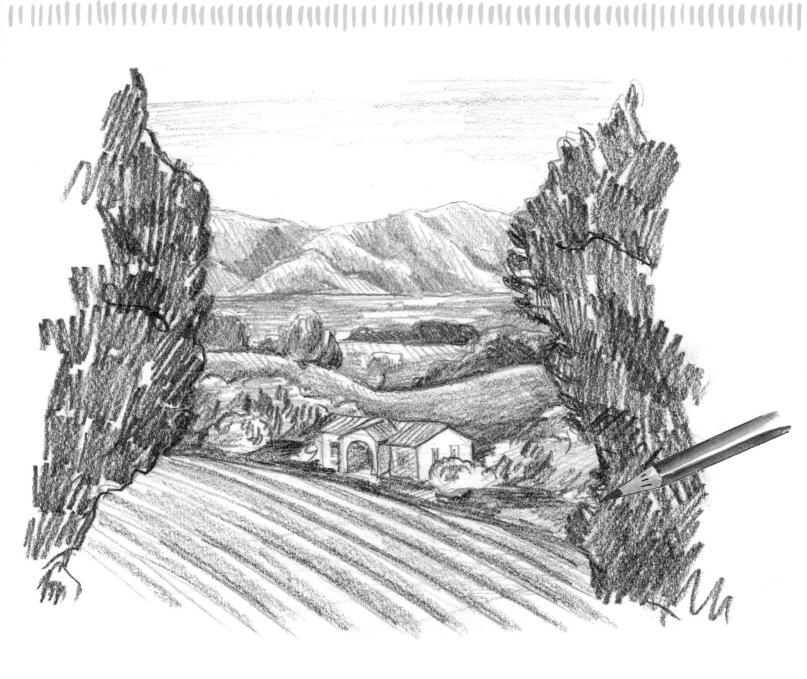

As you add the shadows to the hills and trees closest to you, build up the layers more or use a softer pencil so they're darker. In this sketch, I used a 6B on the closest hills and saved my darkest pencil for the two framing trees.

PORTRAIT

Drawing houses or buildings with a flat view can be fun as well, and they make lovely portraits. You can simplify the subject into basic shapes and give it a more illustrated look with pen and watercolors.

Start by breaking the house down into basic shapes—rectangles, trapezoids, and squares. Be loose and light with your marks until the proportions and sizing are right. I usually sketch freehand first, before going in with a ruler to straighten the lines and angles.

Next divide the building in half. This particular house has a symmetrical facade, so the line down the center will help determine if each side is even and ensure that the windows and doors are symmetrical. Lightly start marking in any exterior details, such as shrubs, fences, trees, windows, etc.

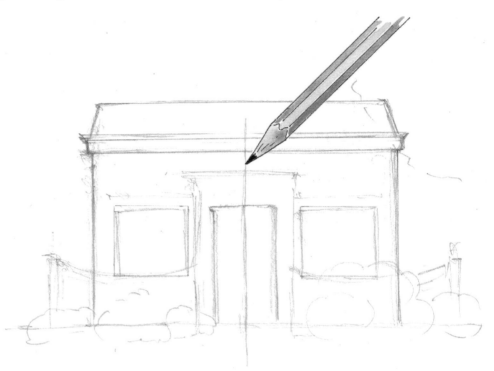

Start breaking it down into more detail by adding windowpanes on the door and posts to the fence.

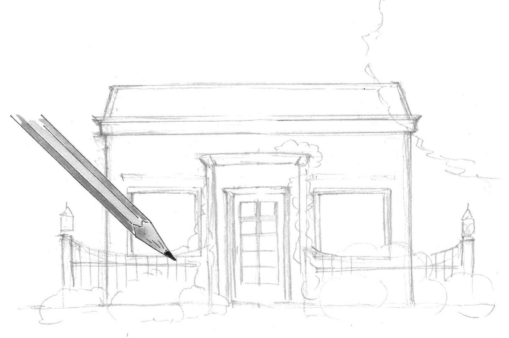

Finish the details with pencil and trace over your lines with a fine-point waterproof pen. These lines can still be loose and choppy to give your drawing a more illustrative quality. When the pen is dry, erase any visible pencil marks.

Finish with watercolor paint or colored pencils. Remember to start with the lightest colors before building up shadows. Preserve the white of the paper for the highlights.

PEOPLE & FIGURES

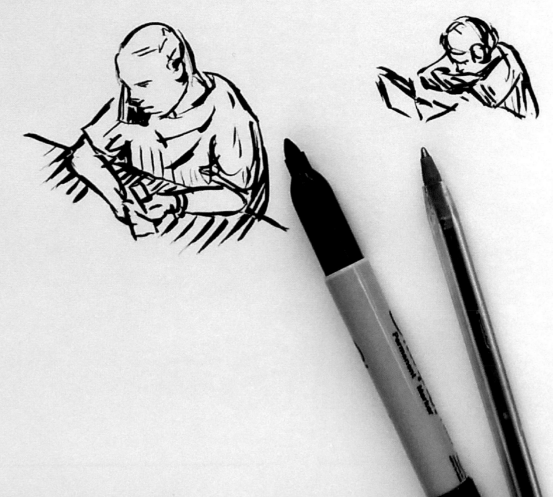

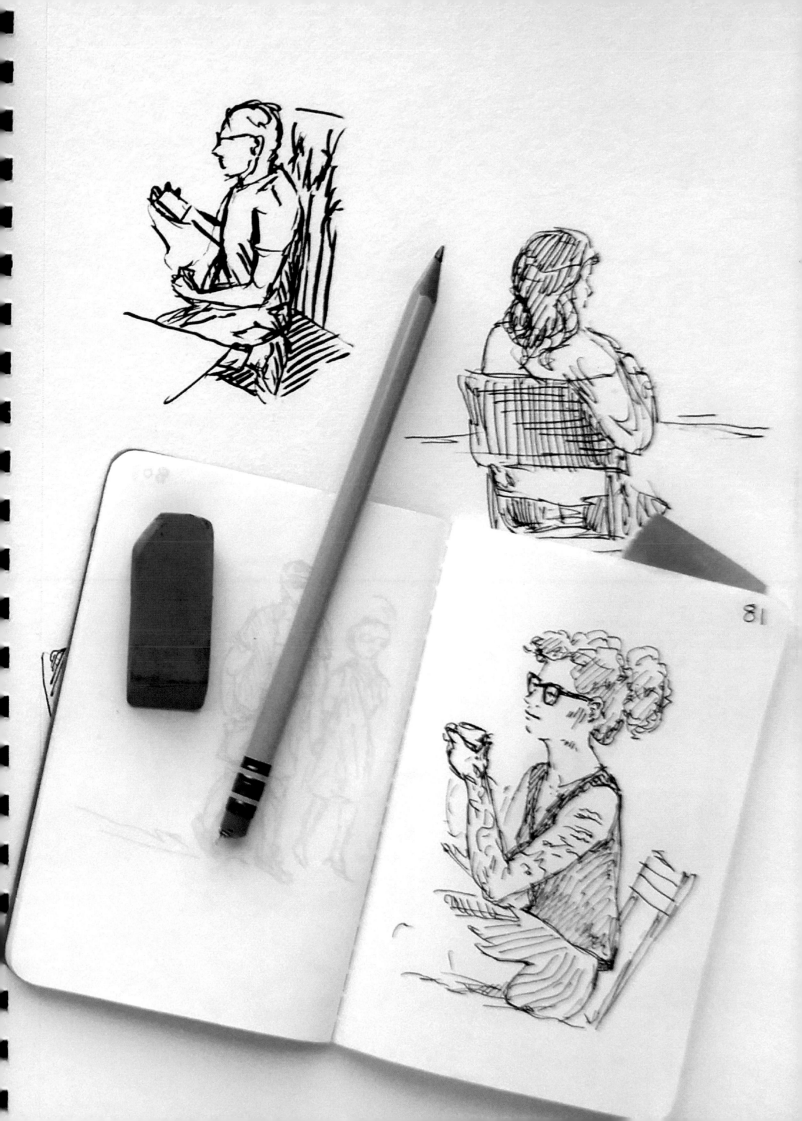

STUDIES

Next to architecture, people may be the hardest subject to draw. It can feel awkward to ask someone you know to model for you—and even trickier to draw a stranger, who may get up and walk off at any moment.

My favorite method for drawing people and figures is gesture drawing—quick and loose to convey lots of movement and energy. The fast mark-making also helps when drawing people out in public who may actually be walking or moving quickly.

PROPORTIONS

Even though each person is completely different and unique, the human body tends to follow the same rules of proportions. The average person is seven to eight heads tall, relative to the size of the drawing. Each person has a different-sized head, so the number of heads tall they are is in proportion to their own head size.

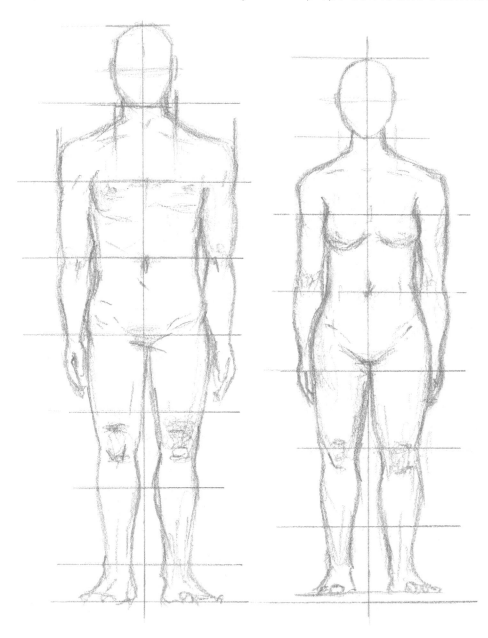

Men tend to be closer to eight heads tall, while women can be seven heads or shorter. You can also use the width of a person's head to measure how broad their shoulders are. Men's shoulders are usually three heads wide, while women are generally between two and a half to two and three-quarters heads wide.

There are also some great measuring tricks for achieving the right facial proportions. While most faces appear symmetrical, it's rare to find one that truly is. I still draw a line straight down the middle of a face to help me sketch everything evenly. If you split the head in half from top to bottom, you'll find the center of the face, where the eyes should fall.

Toward the top of the head is the hairline. The space that's left below can be divided into thirds: the forehead, eyes to the base of the nose, and base of the nose to the chin.

Use the size of the eyes to gauge if the width of the face is correct. Most faces are five eyes wide if you measure from the outer edge of the ears, leaving space equal to one eye between the two eyes.

The middle third gives you the proper length of the ears. Most people's ears are the same length as the distance between the bottom of the eyebrows and the base of the nose. Most noses are the same width as one eyeball.

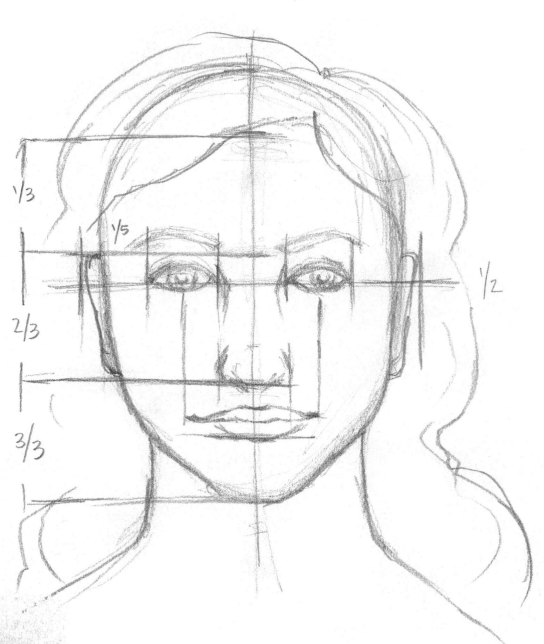

ARTIST'S TIP

Each figure is different, so these rules of proportion aren't finite. Proportions vary from person to person, so don't feel the need to force proportions on a person if they don't apply to that individual.

If you split the bottom third of the face into two, you'll have the proper spacing for the mouth and the chin. Most mouths rest right on top of this line, leaving the rest of the space to be divided between the bottom lip, top lip, and the area between the top lip and base of the nose.

WEIGHT & MOVEMENT

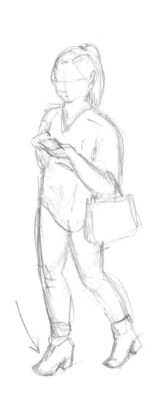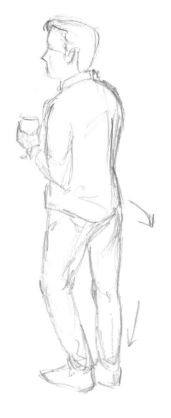

Weight doesn't always mean the literal physical weight of a person, but rather where the subject is supporting more of their weight in a certain position. A figure standing with their feet flat on the ground has their weight centralized, whereas a figure leaning on their right leg has shifted their weight to the right.

Where the figure carries, or directs, the weight influences some of the angles of their body. When studying your figure, determine which leg (or sometimes arm) is supporting the majority of the weight for that position. In some cases, the weight may be shifting away from you.

A figure in motion provides the added challenge of conveying movement! Movement doesn't necessarily mean physical motion—it can be everything from moving arms and legs to the hair or clothing. Keeping your marks loose and overlapping helps convey movement in your figures.

SKETCHING &
ADDING COLOR

Graph paper is helpful when learning to draw figures. Eyeballing proportions can be tricky when you aren't practiced, and it can make your drawings inaccurate and more tedious.

Graph paper provides an instant guide to help ensure your proportions are accurate. These two pages from my sketchbook were made in Rome, Italy. All these people were moving SO quickly that the graph paper really helped me keep the proportions in check.

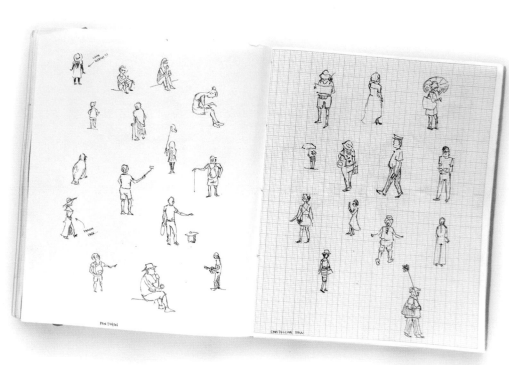

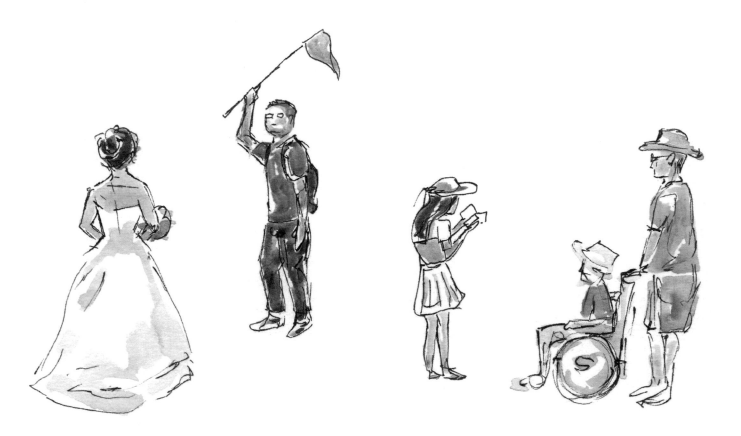

When traveling, or even just around town at home, I love drawing collections of unique people I see out and about. I keep these drawings loose and sketchy, and I usually use a waterproof pen so I can add color right away. Unless there's a very memorable outfit, I always try to leave time to add color on-site to make the most accurate drawing.

These people collections can be quick and very rough, especially when drawing lots of moving people. It's rare that I get to make a very detailed drawing of a person while I'm out and about without asking for permission and the person then knowingly sitting still for a while.

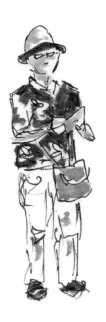

ARTIST'S TIP

For adding color while out and about, I use my travel watercolor set and a small water brush. Since they're travel-sized, it's easy to keep them with me in case I stumble across a person I really want to draw.

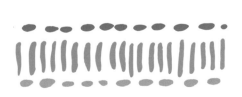

FIGURE DRAWING EXERCISE

With most figures, I usually sketch from the head down. Even if there is a really unique feature that I want to capture, I like to get the proportion of the head correct so the rest of the proportions fall into place. This also gives you a unit of measurement to guide you in drawing the height of the figure.

Sketch the head first, and then loosely sketch a few lines for the rest of the figure, using very light lines for the tilt of the hips and legs so you can easily erase any mistakes.

Once the height proportions are in place, start adding the rest of the arms and legs. At this point, you can also sketch in lines for clothing and any accessories.

This figure's weight is on her right leg and shifted away from the viewer. Knowing where the weight is shifted will help with shading. Add more detail in the clothing and start adding light hatch marks to indicate where to add more shading, or directional marks to indicate curves on the figure.

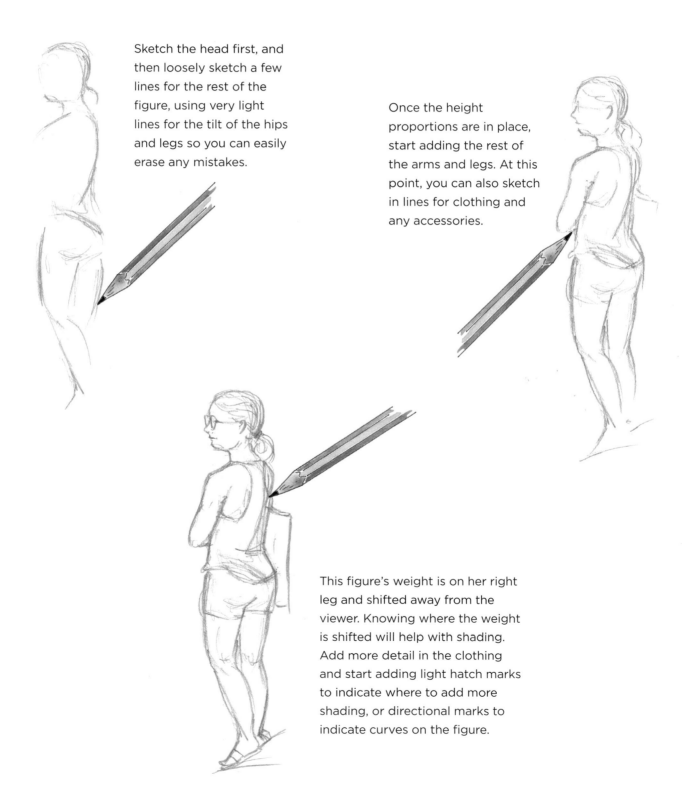

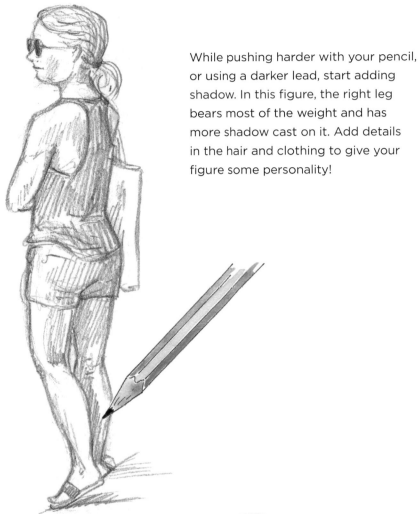

While pushing harder with your pencil, or using a darker lead, start adding shadow. In this figure, the right leg bears most of the weight and has more shadow cast on it. Add details in the hair and clothing to give your figure some personality!

If you'd like to practice drawing figures without going out around town, there are plenty of other options! Magazines are a great source, as well as TV shows. There are also plenty of great stock images online of people in motion or doing a variety of activities.

When in doubt, draw yourself! Whether from a reflection in the mirror or a photo, you're never too old or young to draw a self-portrait!

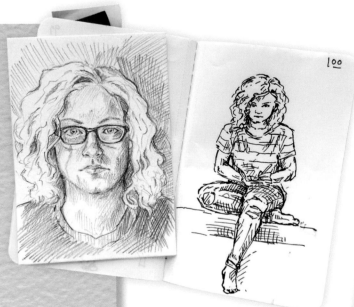

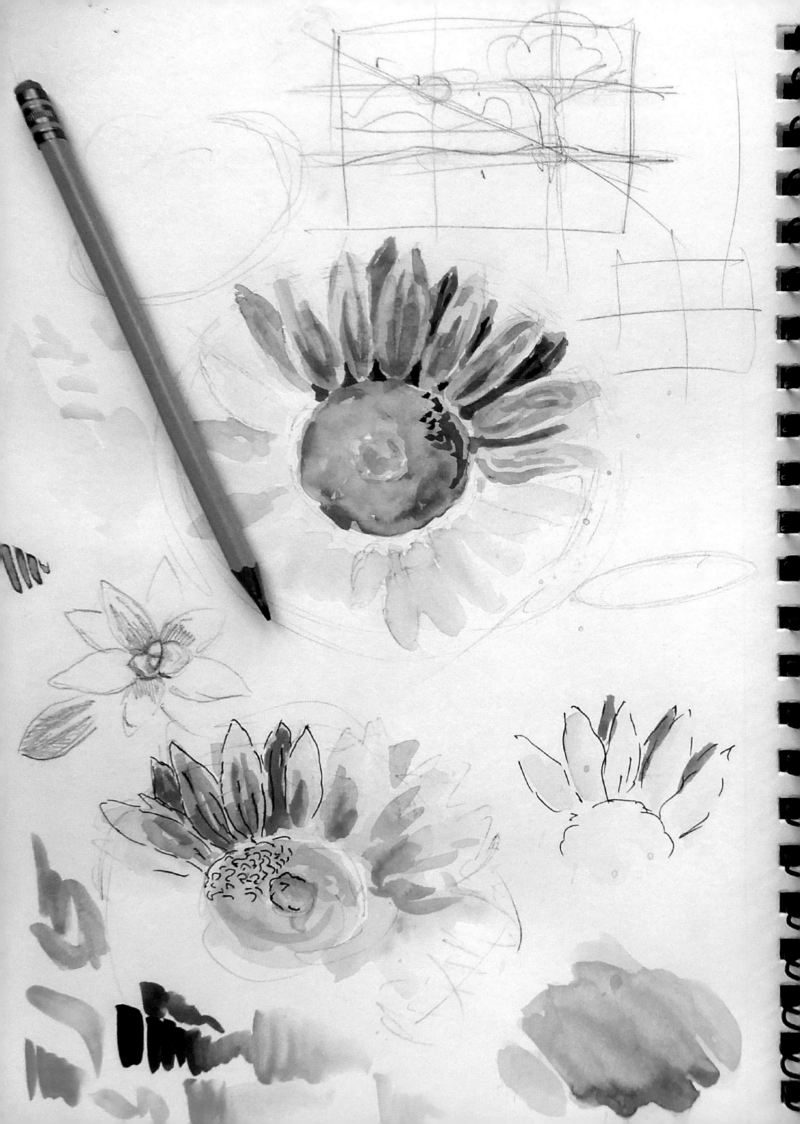

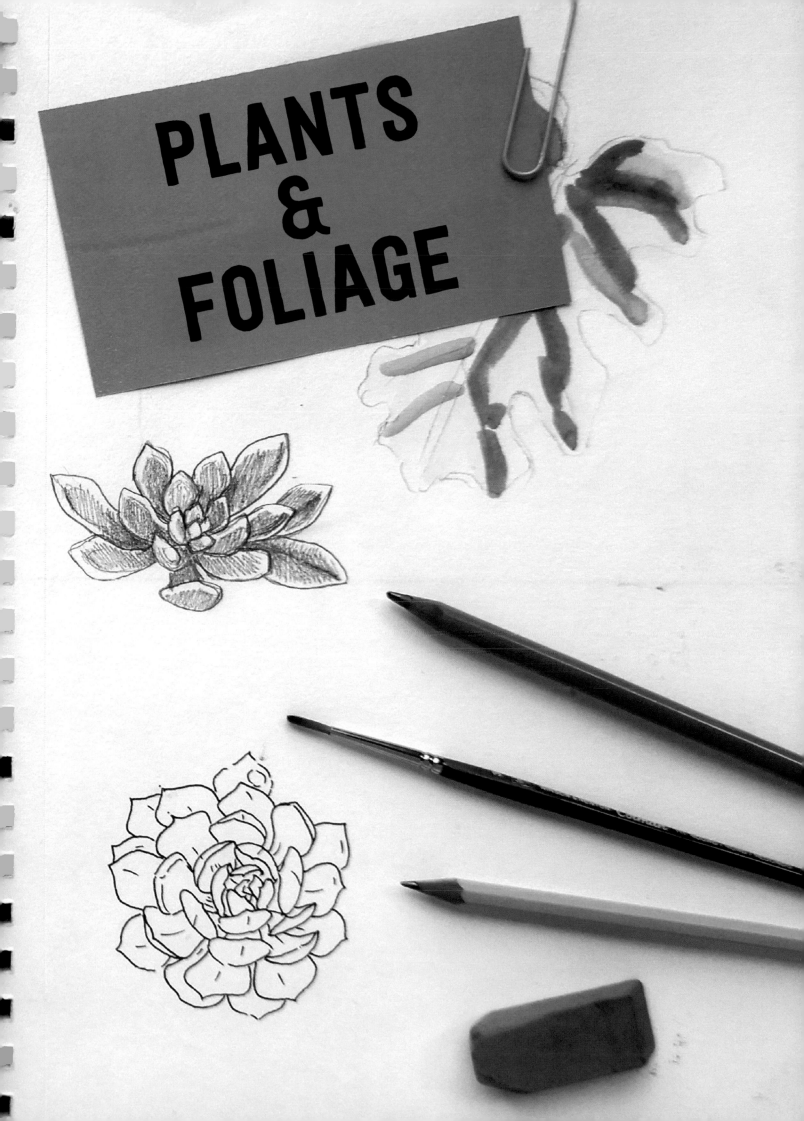

PLANTS
&
FOLIAGE

GETTING STARTED

One of the things I enjoy about drawing plants and foliage is that they're very forgiving subjects. Since they're organic shapes, no two leaves, trees, flowers, or petals are the same—no matter how much they may look alike.

Unlike buildings, which can seem incorrect when a single angle is slightly off, nature drawings appear more lifelike with irregularities—just like their living counterparts. They also tend to reflect more of the artist's personality, since they can be more loose and flowy.

GRAPHITE

As always, I recommend practicing in pencil first. However, since nature drawings can be loose and freeform, they're perfect for experimenting with jumping straight to ink! There's no wrong medium when working with organic objects. You can combine media, and experiment as much as you like.

COLORED PENCIL

INK

Starting with basic shapes is always helpful. With plants, you can start with the very basic components—petals and leaves! These are often the simplest and smallest shapes on a plant, and they come in multiples, so you have many opportunities to practice. Some are football-shaped, ovals, or almond-shaped, like the petals of a sunflower. In more complex flowers, like hydrangeas, the petals themselves can even look like mini flowers.

No two leaves or petals are identical, and each type of plant offers different types of leaves to draw. Maidenhair fern leaves are very different from sage or philodendron leaves, for example.

Drawing plants and foliage from life can seem daunting, with so many leaves and potential for detail. However, I firmly believe that drawing from life results in more realistic drawings. With a photo, the camera has already done the work of translating a 3-D object into a flat, 2-D image. You also lose a lot of subtle nuances, such as the way a shadow falls on a leaf, or the way a branch shifts in the wind.

Sometimes it's impossible to draw plants or foliage from life, and that's just fine. But whenever possible, I highly recommend working from life to build your visual vocabulary. Even if it's a faux plastic flower, don't let the camera do half the work for you!

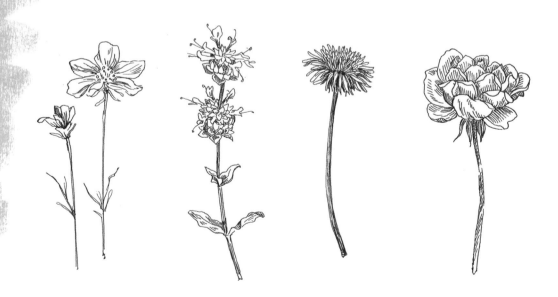

Flower studies are particularly useful when learning to draw. Each flower is unique and changes, depending on the vantage point or angle. When looking at a lot of flowers at once, such as in a bouquet, a field, or a bush, start with one flower and create one, detailed drawing study.

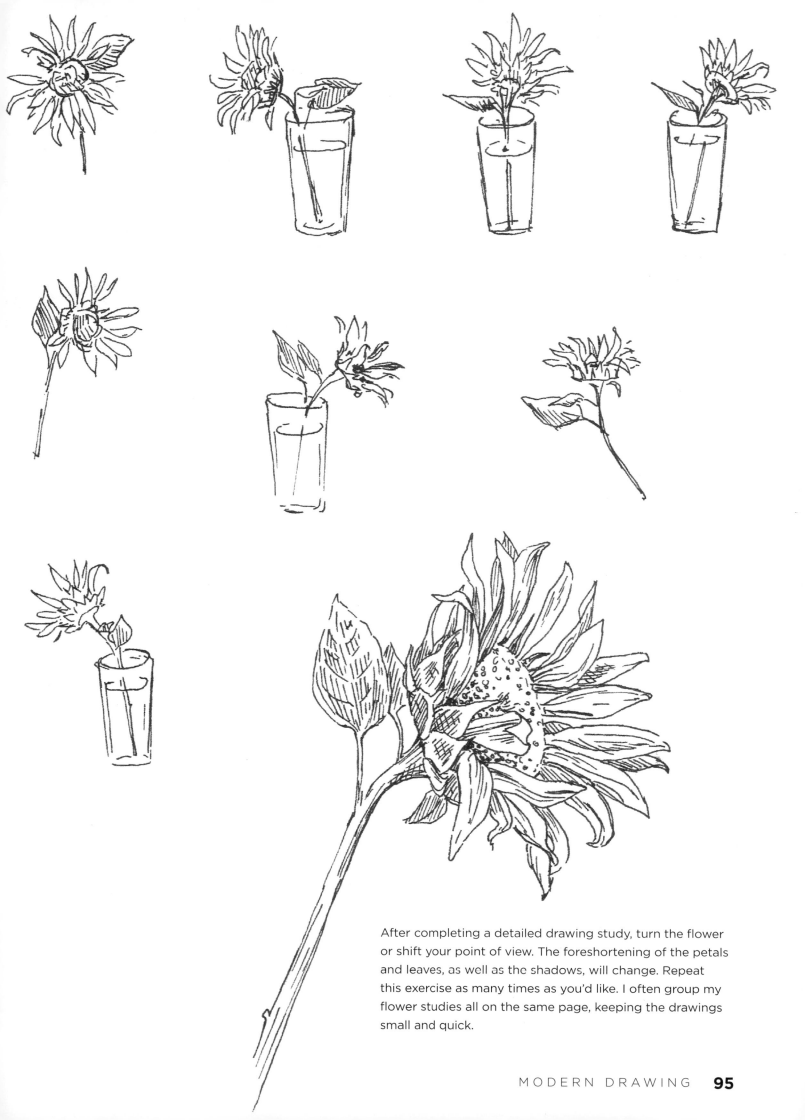

After completing a detailed drawing study, turn the flower or shift your point of view. The foreshortening of the petals and leaves, as well as the shadows, will change. Repeat this exercise as many times as you'd like. I often group my flower studies all on the same page, keeping the drawings small and quick.

DRAWING
FLOWERS

How you approach your drawing style and materials may be determined by what plant or flower you're drawing. If I'm drawing a white or light-colored flower, I often opt to preserve the white of the paper, instead of adding the white with paint or pencils. Unless you're working on toned paper or a colored background, preserving the white of the paper for the white of the flower helps it appear more realistic.

QUICK GRAPHITE STUDY

Regardless of what flower you choose to draw, start by breaking down the basic shapes. For these daisies, that includes the circular center and the outer circle that is created by the petal edges.

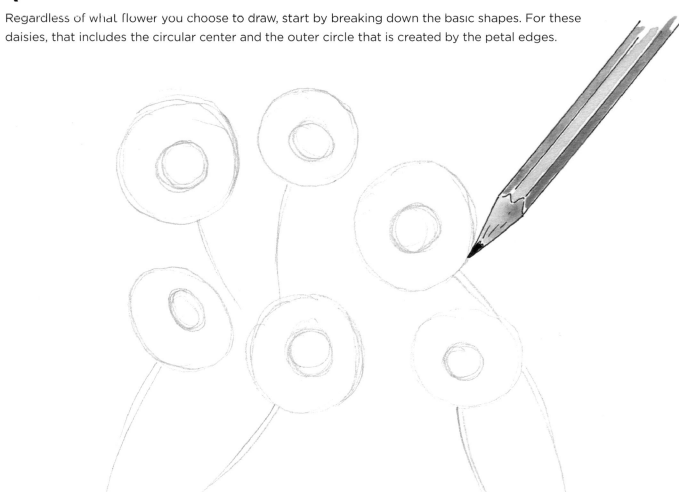

ARTIST'S TIP

When drawing a flower with lots of visible petals, start by lightly sketching the overall shape of the flower, rather than the individual petals.

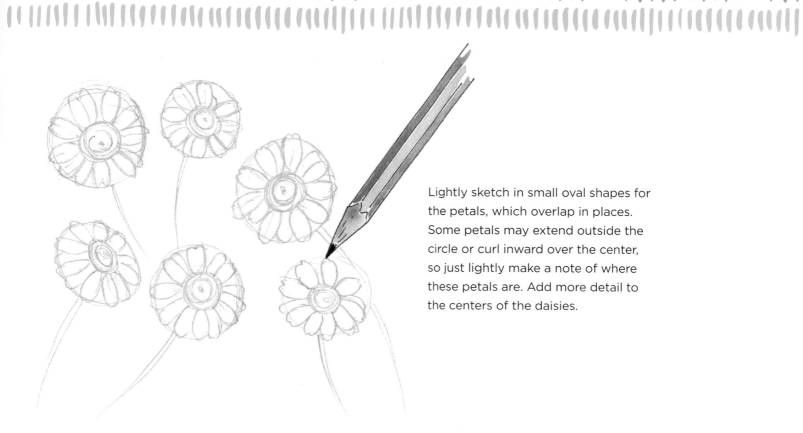

Lightly sketch in small oval shapes for the petals, which overlap in places. Some petals may extend outside the circle or curl inward over the center, so just lightly make a note of where these petals are. Add more detail to the centers of the daisies.

Start shading around the outside of the daisies and stems, being careful not to get any lead inside the petals or stems. Keeping a blunt tip on your pencil makes it easier to cover more area faster, with wider strokes. You can also hold the pencil on its side, so the lead is flat on the page.

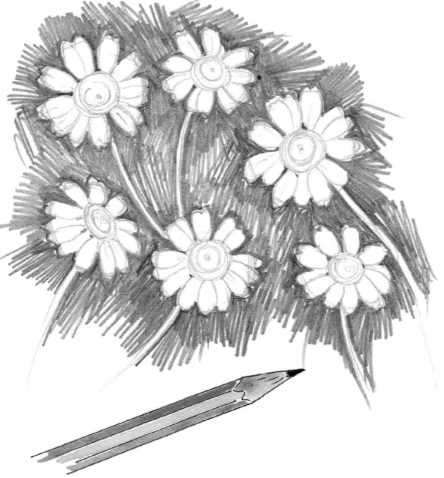

Continue making the background darker, but leave some areas with just the first shading layer for the leaves. Begin adding more detail and texture to the centers of the daisies.

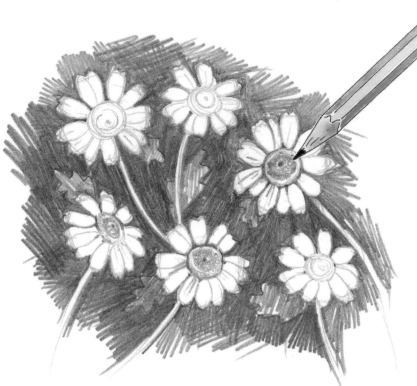

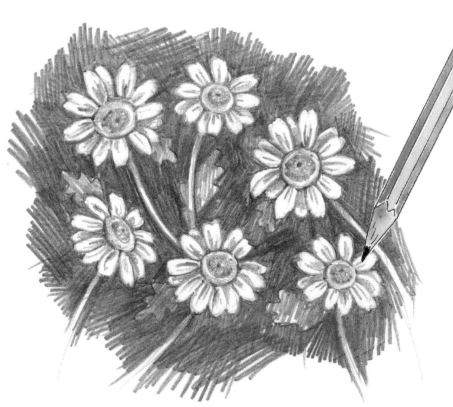

Start adding detail and shadows to the petals. The shadows should be fairly light—not nearly as dark as the background shadows or leaves. Leave areas of paper showing in between the pencil marks on the petals to show their curves. With a fine-pointed pencil, add tiny circles to the centers of the daisies.

INCORPORATING COLOR

As much as I love black-and-white drawings of florals, it's fun to replicate their vibrant colors! There are a few ways to incorporate color into your flowers. You can use color from the very start with watercolors or colored pencils, or you can add it later, like a coloring book. It's up to you!

For this sunflower, the first step is to choose the angle from which to draw it. Then break it down into basic shapes. At this angle, the sunflower has more of an oval shape, since it's being viewed from the side. To help with adding petals in the next steps, sketch some lines to show the direction of the petals. They should radiate out from the center to the edge of the outer oval. Note that some lines point down toward the stem, because some petals are foreshortened at this angle.

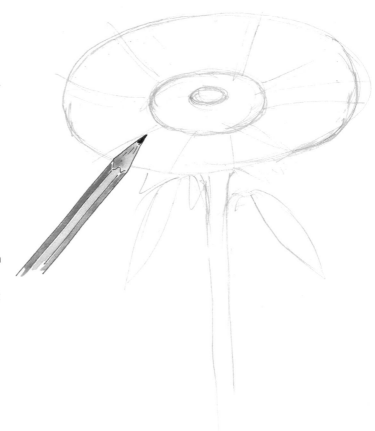

Lightly sketch in the petals. Each petal will be a little different, but most will be a long oval or almond shape. Let some of the petals overlap each other. The petals along the bottom edge are foreshortened and are a squatter, football-like shape.

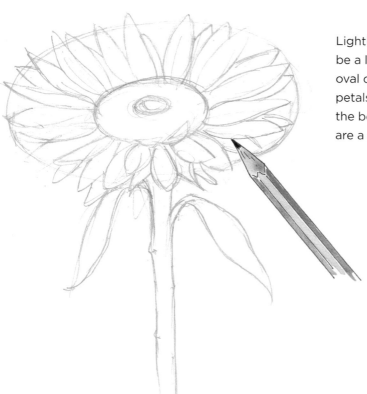

ARTIST'S TIP

When adding color from the get-go, the accuracy of the pencil drawing underneath is crucial. Ensure that your pencil lines and marks are right where you need them, since it's difficult to change your drawing once you start adding color.

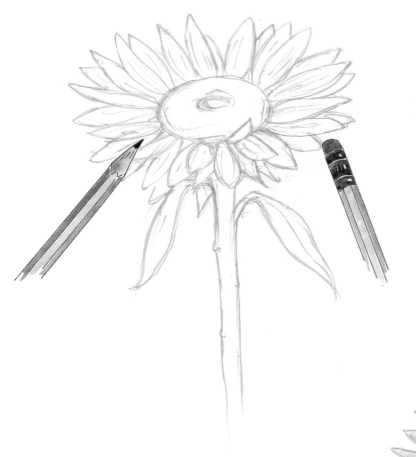

Erase any lines that you won't need for adding color, including the outer oval you drew at the beginning.

Add lines to the petals to indicate the curves or highlights on the shape.

Time for color! I chose to use watercolor, but the steps for adding color in colored pencil or marker are similar.

Start with a base layer of VERY light yellow on the petals and center. On the stem and leaves, add a very light layer of green. When the first layer is dry, add slightly darker yellow on the ridge lines of the petals or the shadows on petals that are underneath another petal. You can also add another layer of green to build up the shadows on the stem and leaves.

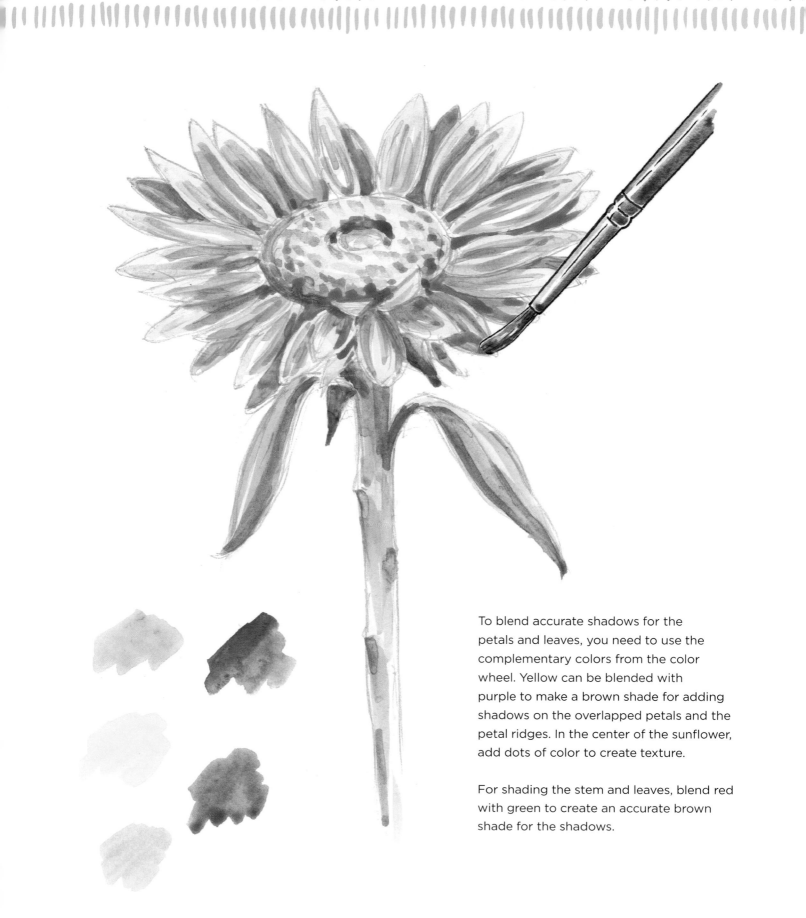

To blend accurate shadows for the petals and leaves, you need to use the complementary colors from the color wheel. Yellow can be blended with purple to make a brown shade for adding shadows on the overlapped petals and the petal ridges. In the center of the sunflower, add dots of color to create texture.

For shading the stem and leaves, blend red with green to create an accurate brown shade for the shadows.

STARTING WITH COLOR

For some flowers, I like to work with color first. For very intricate flowers, creating a color base first works well for capturing details on top with a fine-point pen. These yellow "gold plate" flowers are very intricate—it would be tricky to color each individual pod!

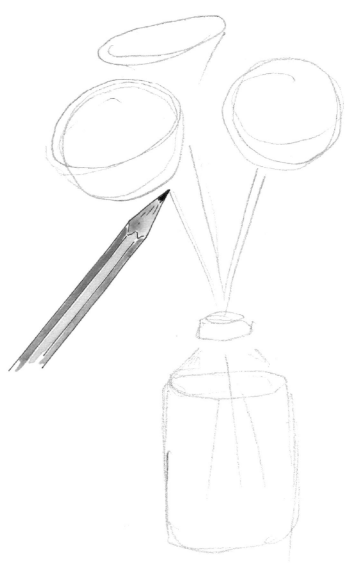

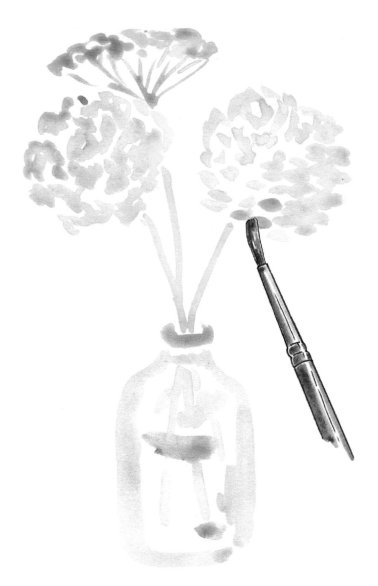

First lightly sketch the shapes of the flowers and the vase. These flowers have long, skinny stems and a conical base of small, individual stems holding up the yellow flower heads.

Watercolor works well here, because it is loose and flowery. I like to keep the color very loose, since I know I'm going to get more detailed with pen later. You could also add color with watercolor pencils and loosen it up after. Erase any pencil lines when the paint is dry.

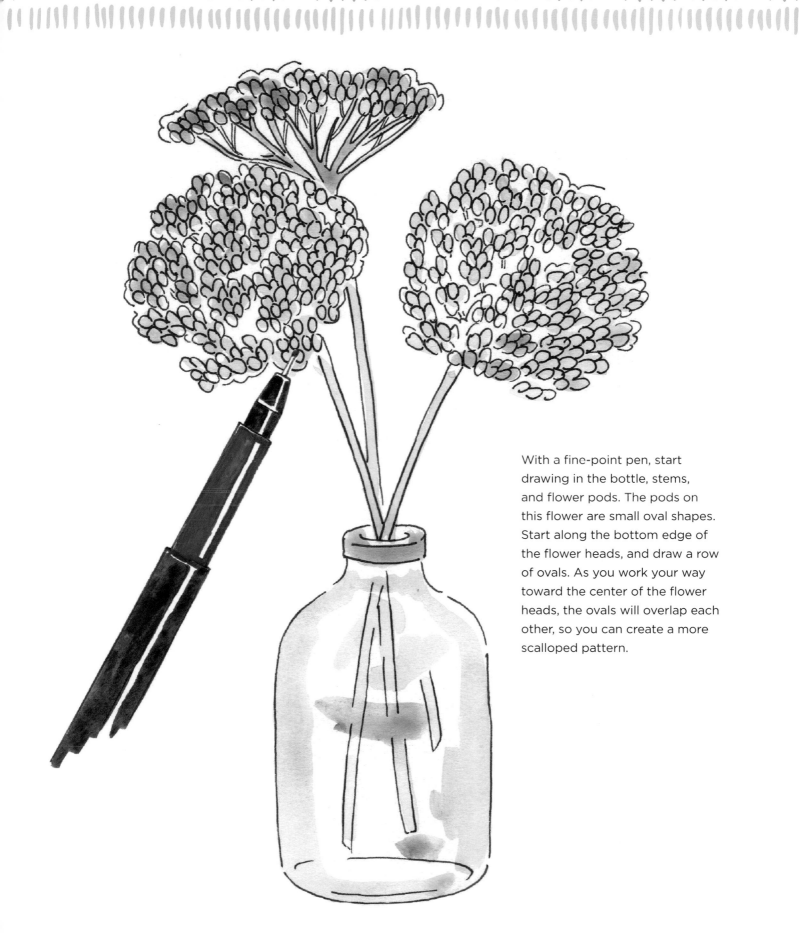

With a fine-point pen, start drawing in the bottle, stems, and flower pods. The pods on this flower are small oval shapes. Start along the bottom edge of the flower heads, and draw a row of ovals. As you work your way toward the center of the flower heads, the ovals will overlap each other, so you can create a more scalloped pattern.

DRAWING
SUCCULENTS

Succulents can be a lot of fun to draw, since many varietals look like flowers. The leaves often form very intricate, geometric patterns that make for a great drawing challenge!

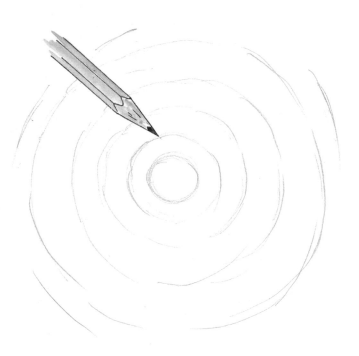

Start by drawing concentric circles. Depending on the size of the succulent rosette, you might draw as many as six circles. These circles will guide you as you draw the leaves out from the center.

ARTIST'S TIP

The centers of succulents often look like crowded clusters, but as you move outward, you'll see a developing, predictable pattern.

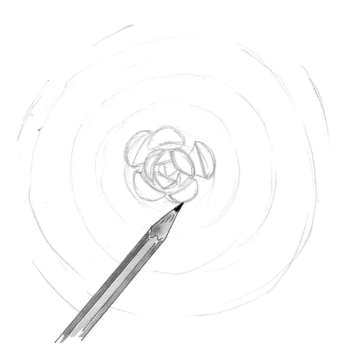

In the very center, draw a small triangle and progressively larger, squat triangles around it. When you reach the next circle, start drawing scalloped shapes or half circles in varying sizes.

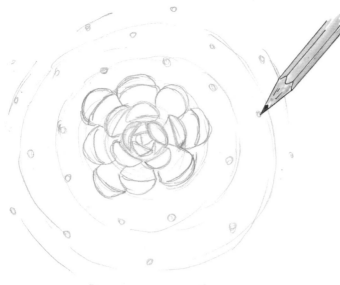

In the third circle, the scalloped shapes line up right next to each other in a ring. Make small marks on the edge of the fourth circle that line up with the space or "V" shape formed by the scallop shapes in the third circle. Continue with the next circle, alternating the marks so they don't directly line up with each other.

As you continue to add leaves, the top of each leaf should land on one of the marks you made along the edges of the circles. The leaves start getting larger and have more of a crescent-moon shape, with long sides going back toward the center.

When you reach the fifth circle, the top of each leaf should be pointier.

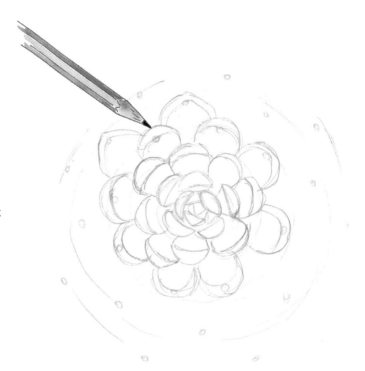

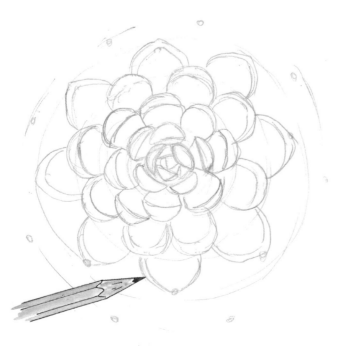

Continue drawing the pointed leaves to complete each circle before moving on to the last layer.

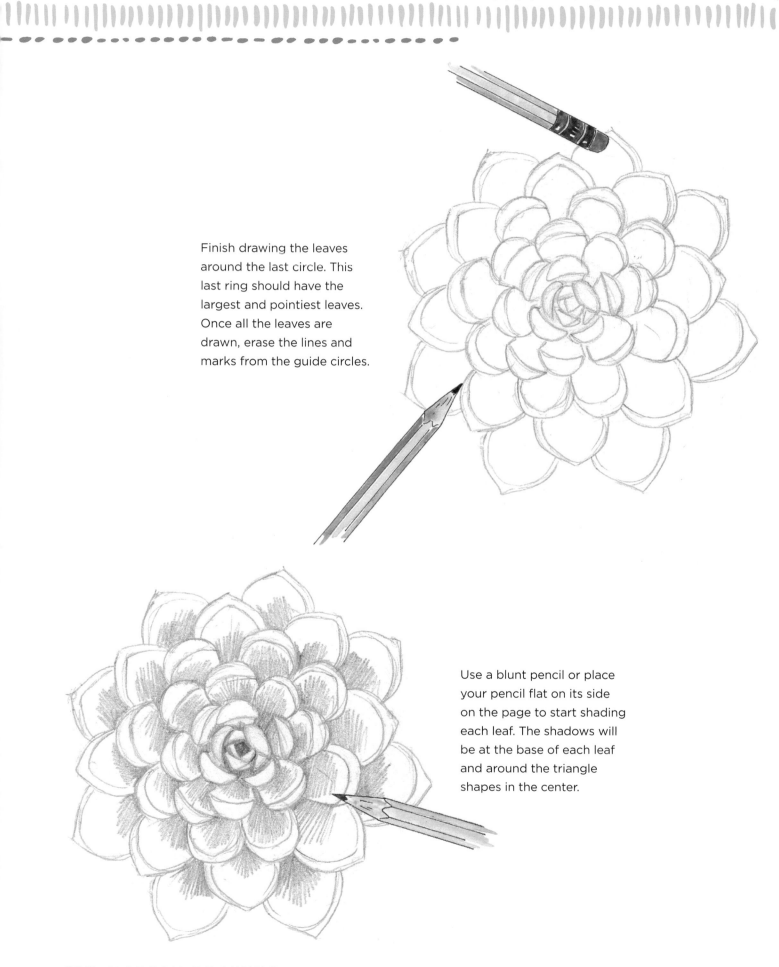

Finish drawing the leaves around the last circle. This last ring should have the largest and pointiest leaves. Once all the leaves are drawn, erase the lines and marks from the guide circles.

Use a blunt pencil or place your pencil flat on its side on the page to start shading each leaf. The shadows will be at the base of each leaf and around the triangle shapes in the center.

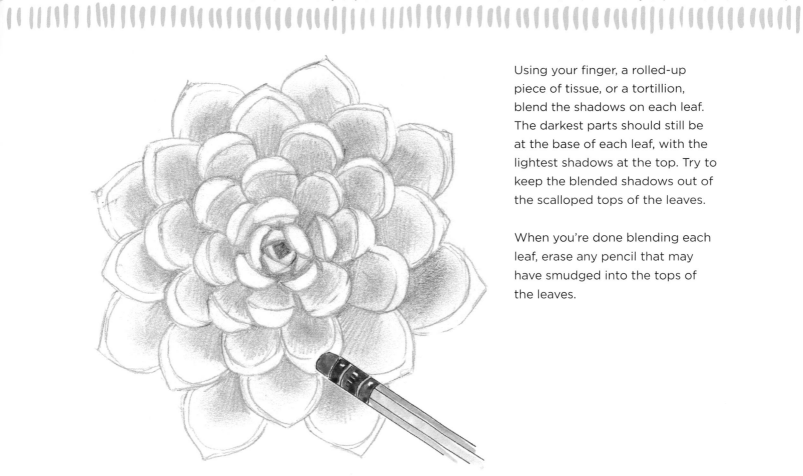

Using your finger, a rolled-up piece of tissue, or a tortillion, blend the shadows on each leaf. The darkest parts should still be at the base of each leaf, with the lightest shadows at the top. Try to keep the blended shadows out of the scalloped tops of the leaves.

When you're done blending each leaf, erase any pencil that may have smudged into the tops of the leaves.

To finish, go back in with pencil and add details to the leaves and darken the shadows so they really "pop!" You want high contrast between the dark shadows at the base of each leaf and the highlights of the white paper left along the top scalloped edges.

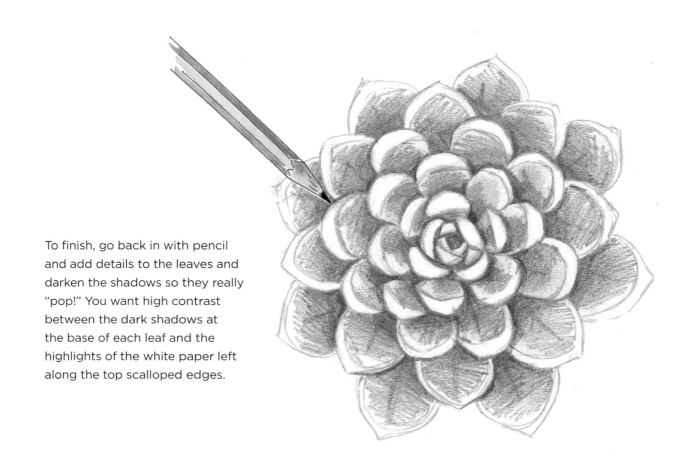

SUCCULENT IN INK

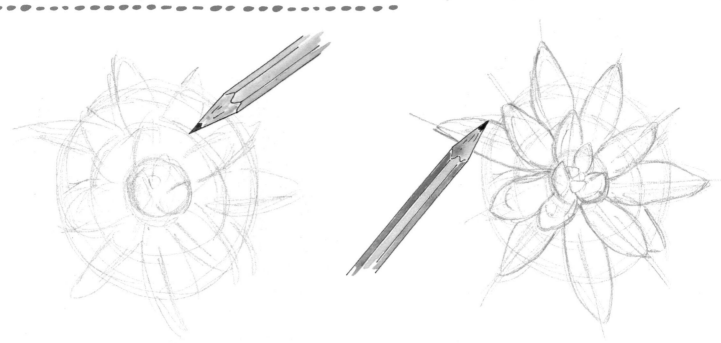

Some succulents are less geometric. This particular succulent has longer leaves that grow more erratically compared to a succulent rosette.

Lightly sketch concentric circles to help with sketching the leaves, as well as some overlapping triangles and half circles in the center.

Start defining the succulent leaves. Each of these long leaves radiates straight out from the center—you can sketch straight lines as a guide.

The leaves in the center circle are foreshortened, since they're growing straight at you. The last circle has the longest leaves, which are elongated almond shapes with irregular sides.

With a water-soluble pen, sketch the outer lines of the leaves. Add some detail lines on the leaves to show their ridges and give you more ink to work with later.

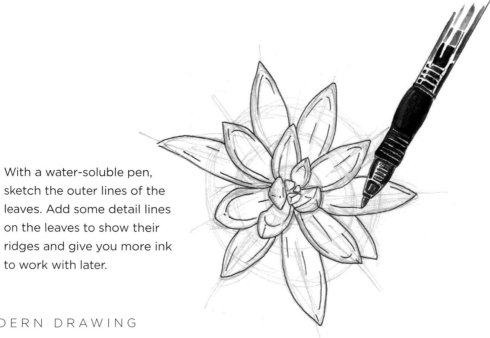

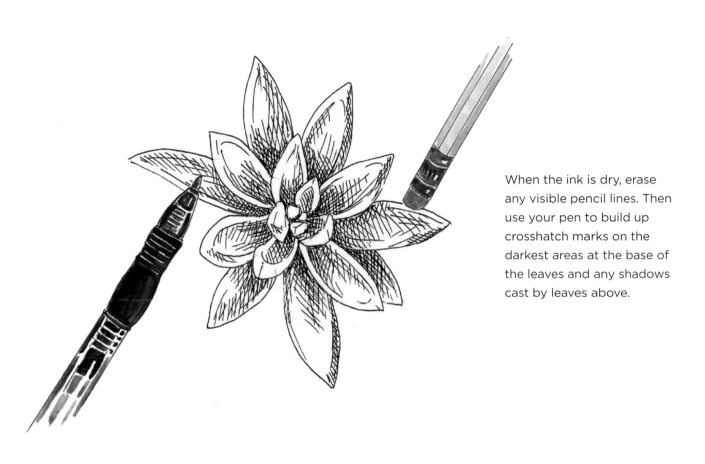

When the ink is dry, erase any visible pencil lines. Then use your pen to build up crosshatch marks on the darkest areas at the base of the leaves and any shadows cast by leaves above.

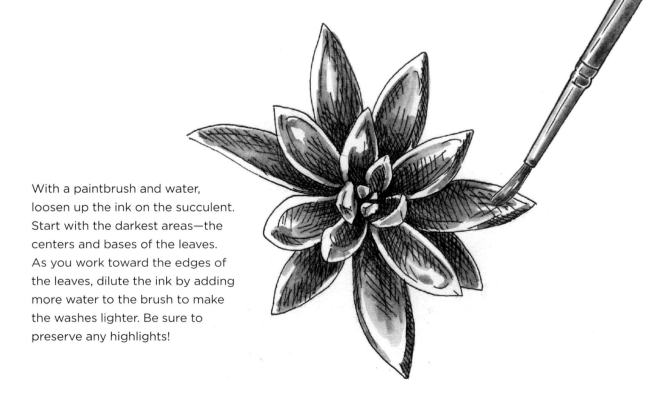

With a paintbrush and water, loosen up the ink on the succulent. Start with the darkest areas—the centers and bases of the leaves. As you work toward the edges of the leaves, dilute the ink by adding more water to the brush to make the washes lighter. Be sure to preserve any highlights!

Succulents are one of my favorite plants to draw, since there are so many variations—
each with a unique and unusual shape. Besides the rosette or more flowery shapes,
you can also draw individual stalks and stems, or even small clippings!

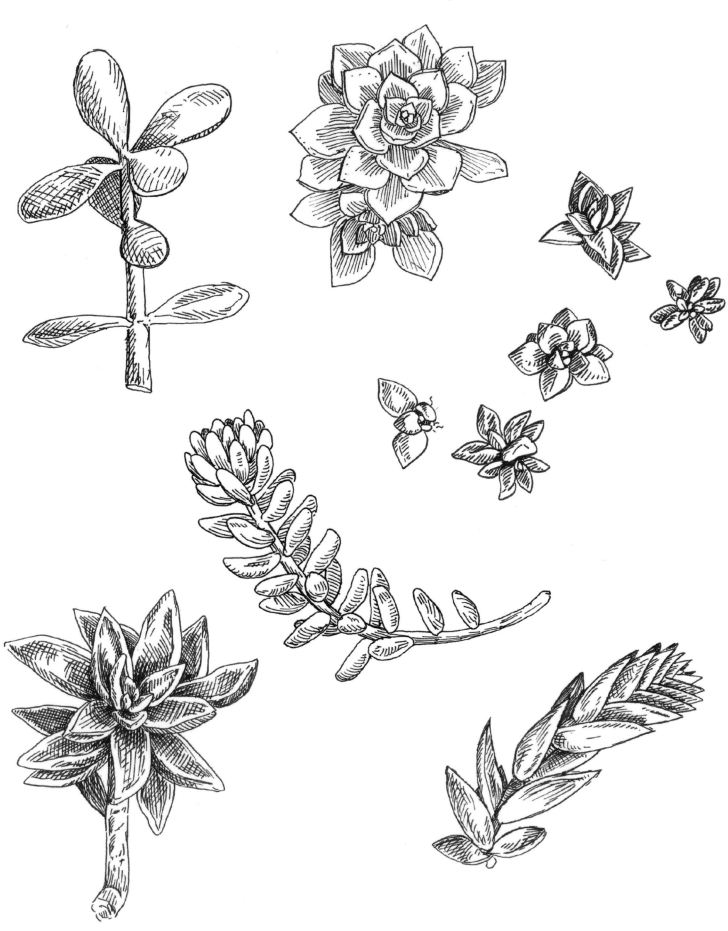

DRAWING
POTTED PLANTS

As you work your way to larger plants, your drawings will become more complicated. Potted plants and trees are great for sketching, because it gives you the challenge of drawing subjects larger than your paper. You must translate a larger 3-D object into a smaller 2-D drawing. This can take practice, so be patient with yourself!

Potted plants are a great stepping stone. Nurseries or garden shops have a wide variety if you don't have your own at home to draw.

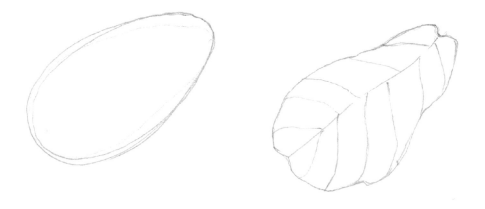

Fiddle leaf fig plants are great for practice because the large leaves are simple teardrop or oval shapes.

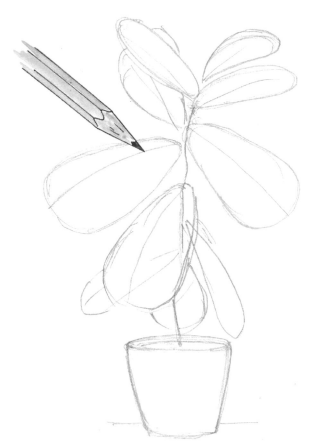

Sketch the pot, paying attention to the curve of the top edge if you can see inside the pot. Lightly sketch the center stem and teardrops and ovals for the leaves. Draw a center vein down the center of each wide leaf that faces you.

Start refining the shapes of the
leaves. Make the edges irregular
with an inverted tip at the front.
For leaves that are turned away
from you, sketch the farther edges
if they're visible. Very lightly sketch
the rest of the veins on the leaves.

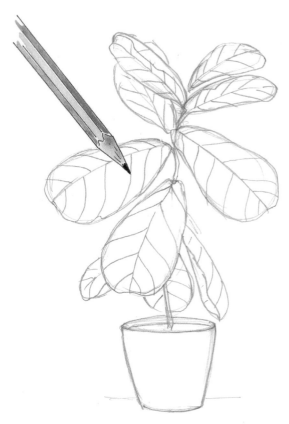

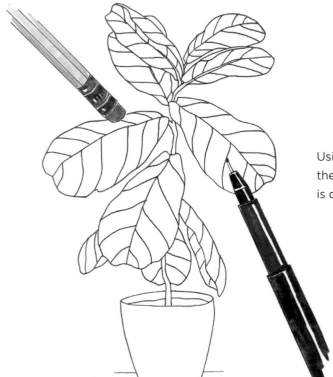

Using a waterproof pen, go over all
the lines on the plant. When the ink
is dry, erase any visible pencil lines.

With your choice of coloring
medium, add a light base layer
of green on the leaves and
brown on the stem. Shade in
the pot as well.

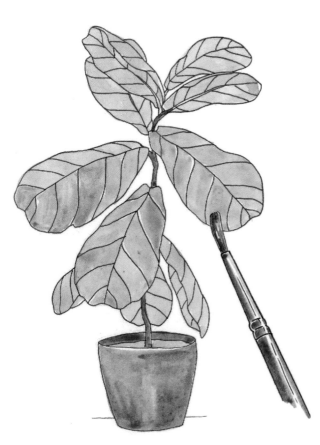

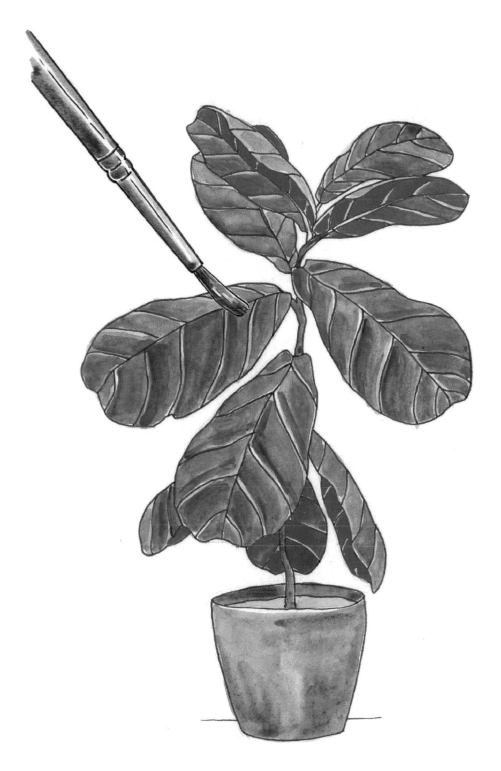

Go over the leaves with a second layer of green, leaving some light spots along the veins and centers. Blend red with your green to create a darker, greenish brown to use for the shadows. Fiddle leaf fig leaves undulate and ripple, so the leaves should all be different. The undersides are darkest. It may take two layers of shading to achieve dark enough shadows.

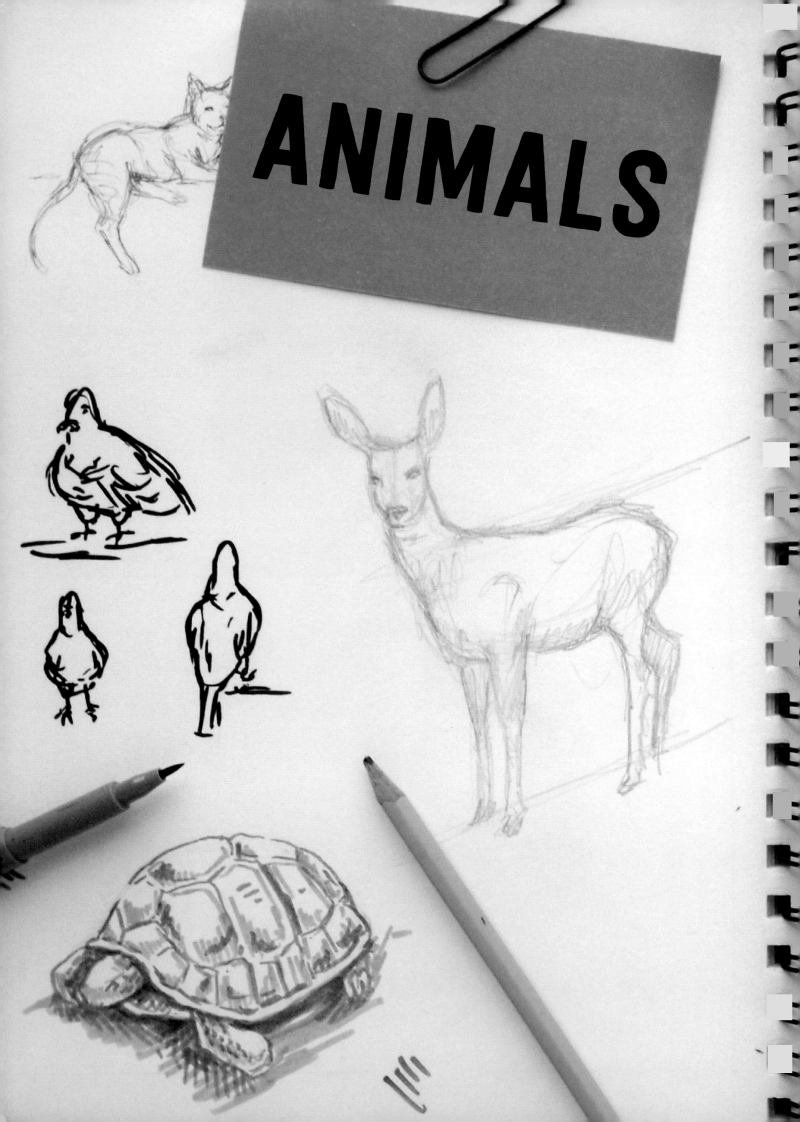

ANIMALS

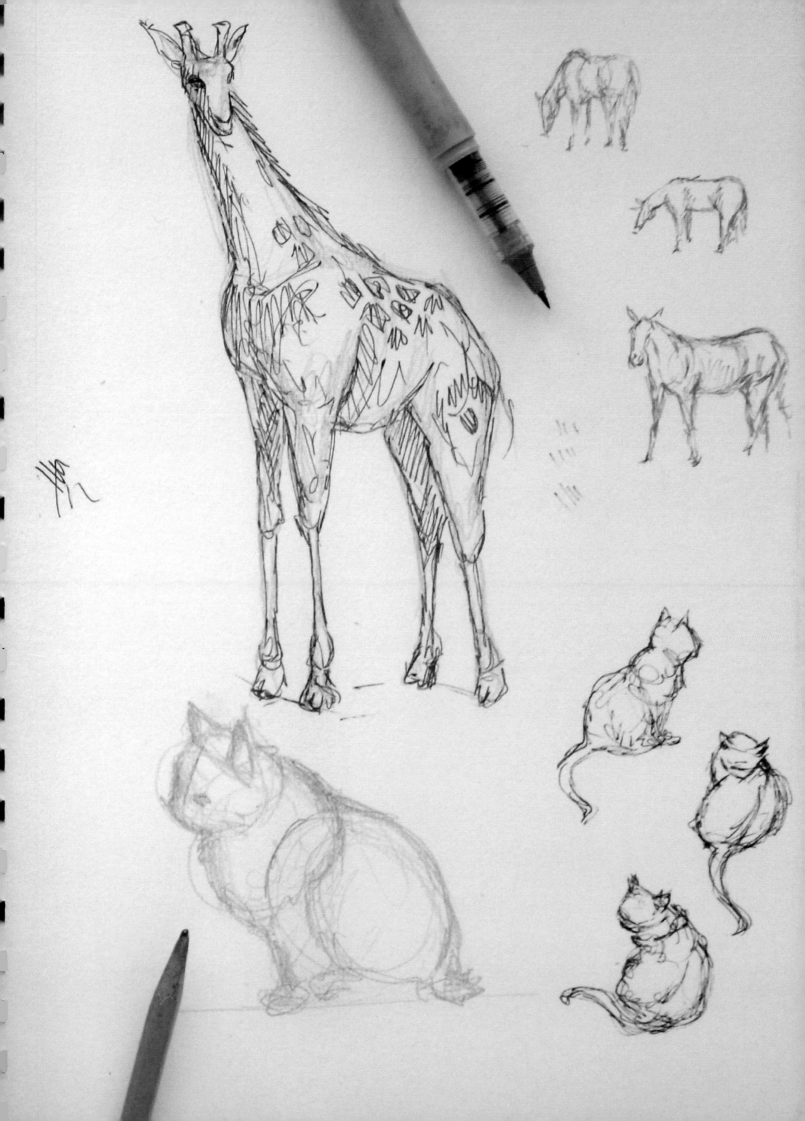

SHAPES & GESTURE
DRAWING

Animals can be a lot of fun to draw, because there is such a wide variety in the world! From your own pets to a visit to the zoo for more exotic critters, animals are everywhere.

I usually draw animals when I'm visiting the zoo. Zoos offer a wide variety of unique animals you may otherwise only have the chance to draw from photos. Natural history museums can be very fun too. Between extinct species exhibits and collections of non-moving animals and insects, you'll have the opportunity to leisurely practice drawing without worrying that they will move mid-drawing.

When I'm traveling, I often collect pages of pigeons or cats. They're fast-moving critters, so my sketches are usually very quick and loose to reflect that!

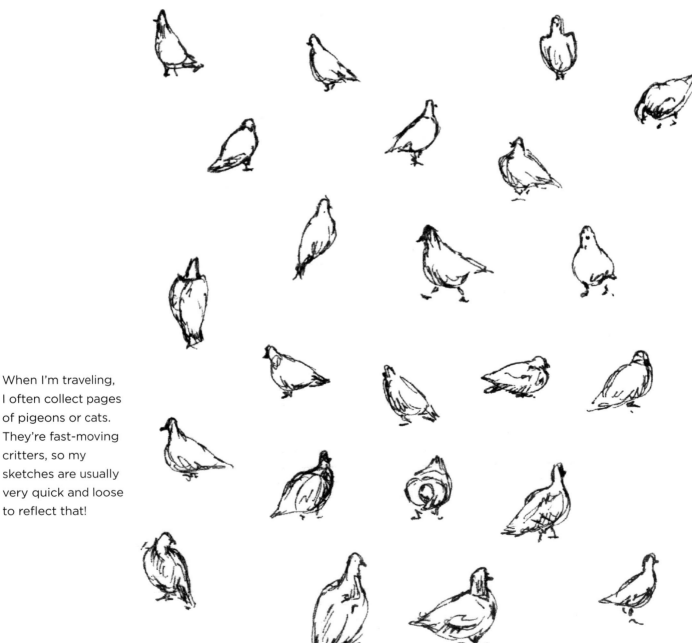

FINDING SHAPES

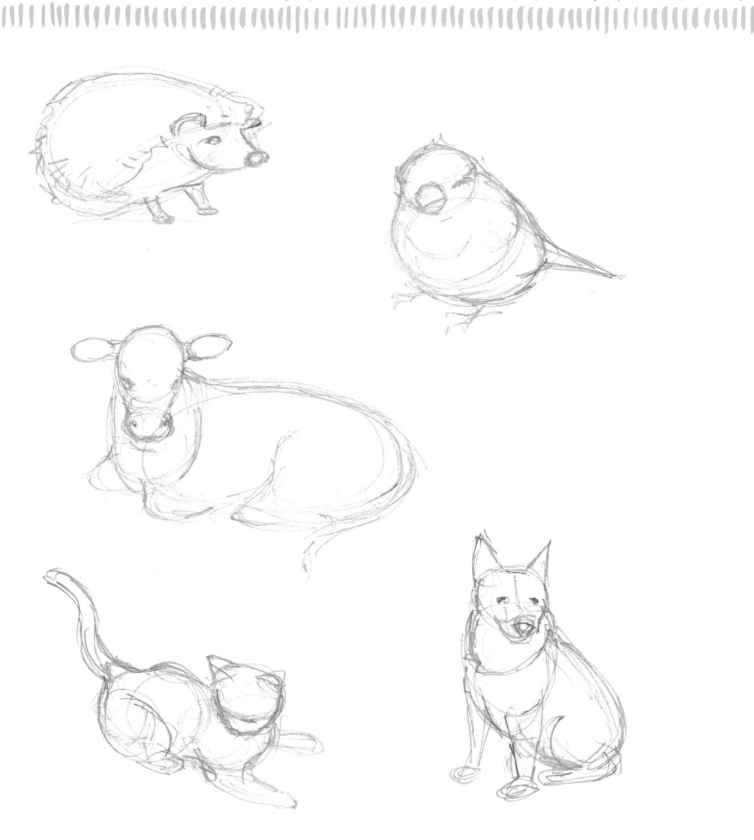

Much like drawing people, you can break down any animal into basic shapes.
Since each animal can vary drastically, the shapes for a cat or dog may be
completely different than for a horse or bird. Just be patient and sketch lightly.
Study the animals on this page and see what shapes you can identify in each one.

GESTURE DRAWING

A great way to start drawing animals is with gesture drawings. These can be done with anything from a pen or pencil to a permanent marker. I personally prefer to use wide brush pens, so the marks can be fast and loose, in case the animal is also moving quickly.

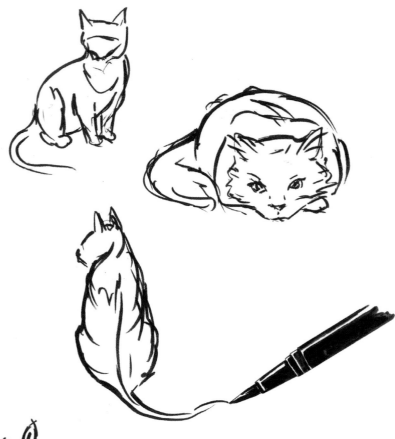

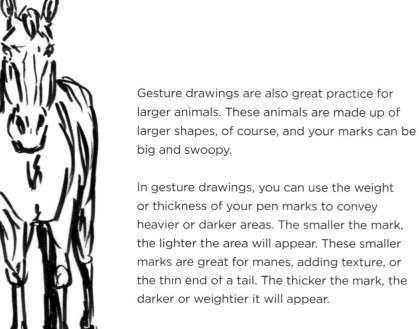

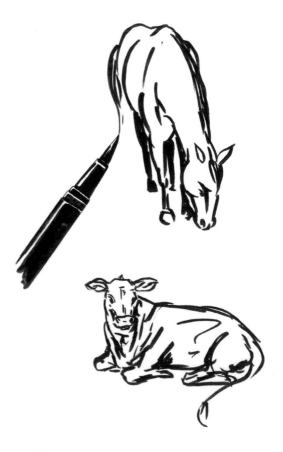

Gesture drawings are also great practice for larger animals. These animals are made up of larger shapes, of course, and your marks can be big and swoopy.

In gesture drawings, you can use the weight or thickness of your pen marks to convey heavier or darker areas. The smaller the mark, the lighter the area will appear. These smaller marks are great for manes, adding texture, or the thin end of a tail. The thicker the mark, the darker or weightier it will appear.

COMBINING MEDIA

There's no wrong medium for drawing. When I draw pigeons, I often switch between adding color first or last—sometimes it's just up to how I'm feeling that day. Either way, it's good practice to try different methods. If I'm working with pen first, I start with a pencil drawing to break down the shapes first, sketching quickly with lots of overlapping lines.

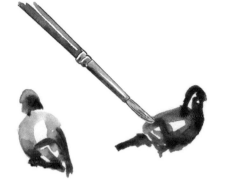

Once the watercolor has dried on the pigeon, go in with a pen—either waterproof or water-soluble—and add the smaller details you can't capture with a brush, such as texture on the feathers, feet, beak, and eyes. These marks can also be quick and loose to help convey movement.

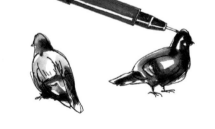

You can also draw with water-soluble ink first, and loosen it up with a brush and water afterward.

DRAWING
CHICKENS

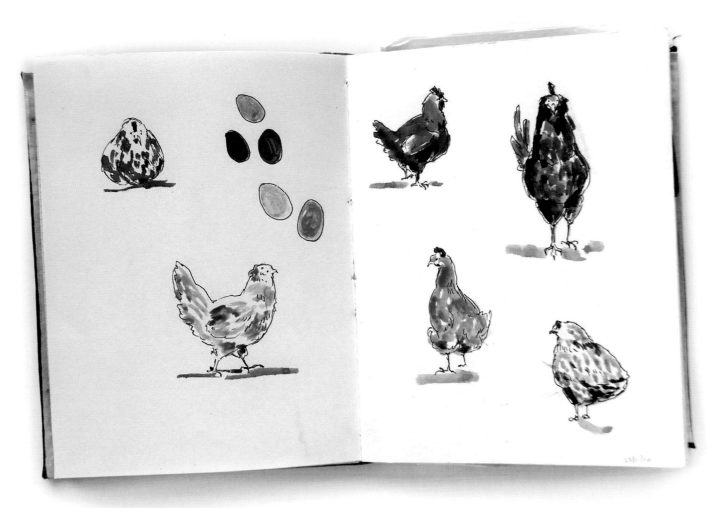

Chickens are very fun to draw because they can each be so different—and plump!

Draw loose, overlapping shapes. Note how the head and neck make one shape. Depending on the chicken, the other main shapes might be the main body, tail end, wings, and the feathery fluff right above the feet.

Connect the shapes so they form one body. You can erase any leftover marks, and then begin adding more details to the face.

Use a softer lead pencil (anything from a B to 7B), an ebony pencil, or just add more pressure with your current pencil to begin building up the shadows. These marks should also add texture in the feathers. Draw the curves to show the changes in direction of the feathers.

For areas that are really light, like the feet, build up the shadows around them to leave the shape of the feet. Add very few marks to light areas of the chicken's body, or leave them entirely white.

Continue to add more graphite to your drawing until you have very dark shadows that contrast against the lightest areas. Erase any rogue marks off the page.

DRAWING CATS ..

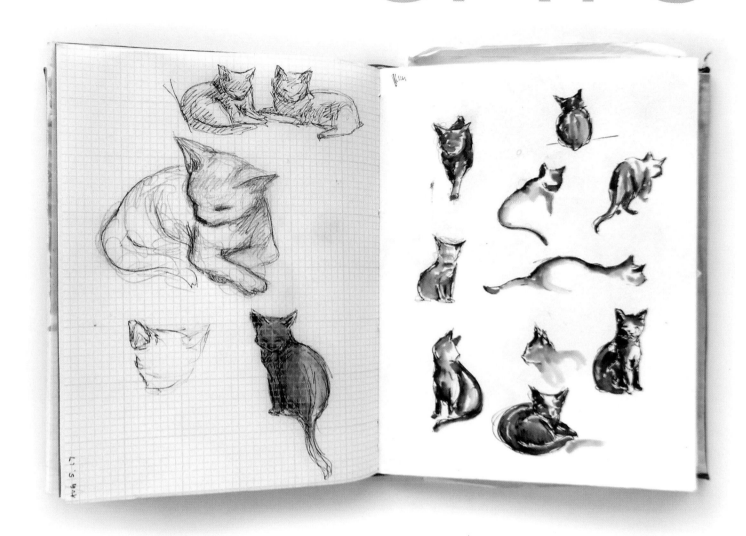

I love drawing cats because of the shapes they can contort themselves into. They're incredibly flexible animals that conveniently sleep for long stretches of time, making them great models to practice drawing!

Begin by breaking the cat into shapes. There are mostly round shapes in the body, head, and paws. The ears and legs are more angular, with long trapezoid shapes for the front legs.

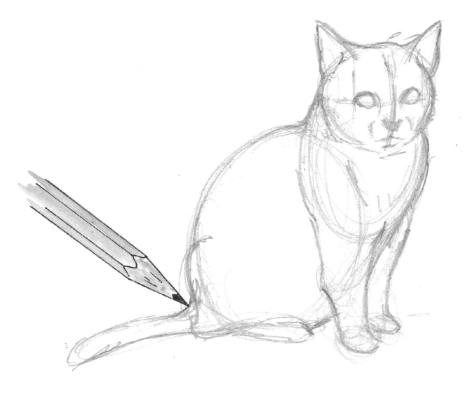

Connect the shapes and erase the lines you no longer need. Start adding more detail in the face. Similar to drawing the face of a person, you can draw a curved line down the center to help place the features.

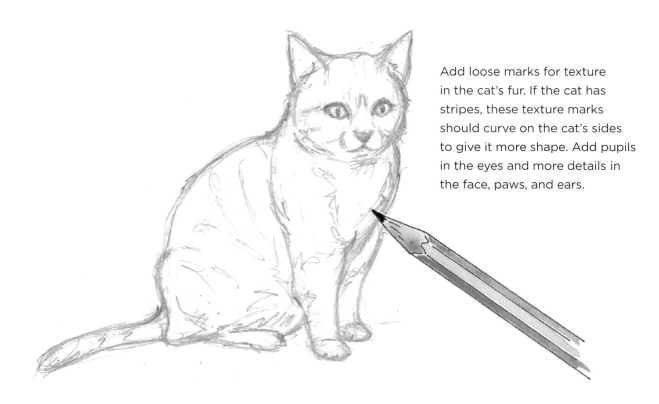

Add loose marks for texture in the cat's fur. If the cat has stripes, these texture marks should curve on the cat's sides to give it more shape. Add pupils in the eyes and more details in the face, paws, and ears.

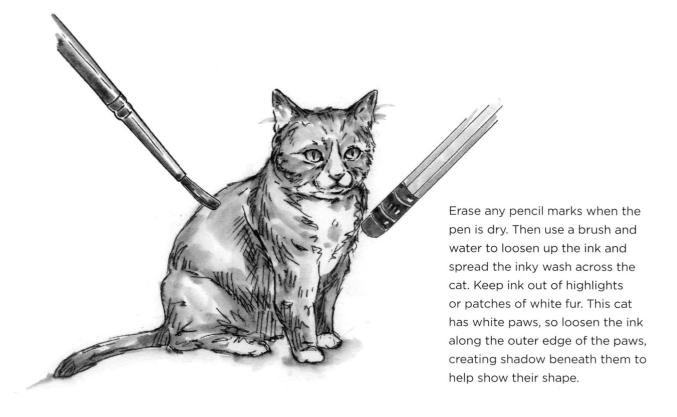

With a water-soluble pen, build up hatch marks in the darkest areas of the cat, such as the stripes in the fur and areas that don't catch much light. Typical areas of shadow are behind and along the legs, across the belly, and underneath the face, but it depends on the light source. Outline the features of the face, including the eyes, nose, ears, and mouth.

Erase any pencil marks when the pen is dry. Then use a brush and water to loosen up the ink and spread the inky wash across the cat. Keep ink out of highlights or patches of white fur. This cat has white paws, so loosen the ink along the outer edge of the paws, creating shadow beneath them to help show their shape.

Using the pen again, go back in and add top marks to show even more texture. These marks can curve along the side of the cat to show changes in the direction of the fur. Build up the darkest shadows on the cat even more. Add whiskers to the face and ears to give it some personality.

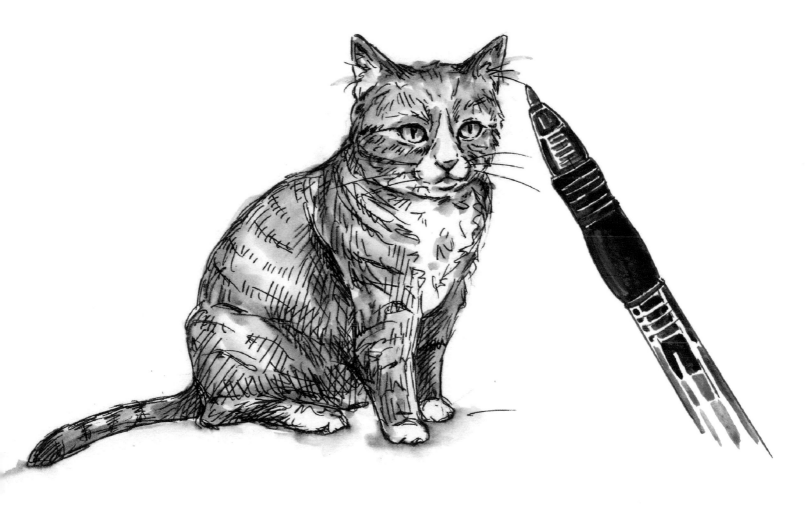

DRAWING
DOGS

Dogs make great subjects, since they sleep for long periods of time and tend to sit still well. They're also fun to capture in gesture drawings!

Break down the dog into shapes. The type of dog determines the number and size of the shapes. For example, a Chihuahua has smaller and fewer shapes than a large Saint Bernard. If you're drawing a hairy dog, try to capture the outermost edge of the hair and any shapes you can see of the actual body under the fur.

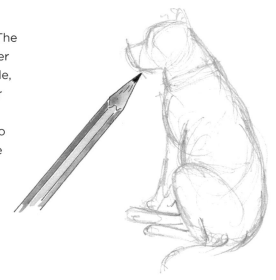

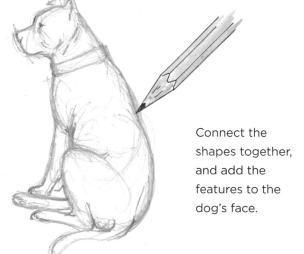

Connect the shapes together, and add the features to the dog's face.

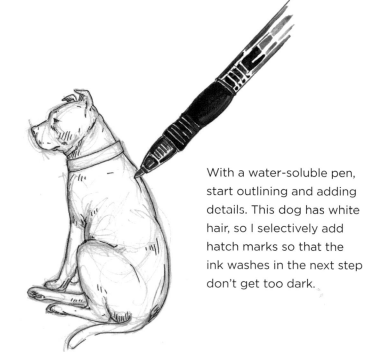

With a water-soluble pen, start outlining and adding details. This dog has white hair, so I selectively add hatch marks so that the ink washes in the next step don't get too dark.

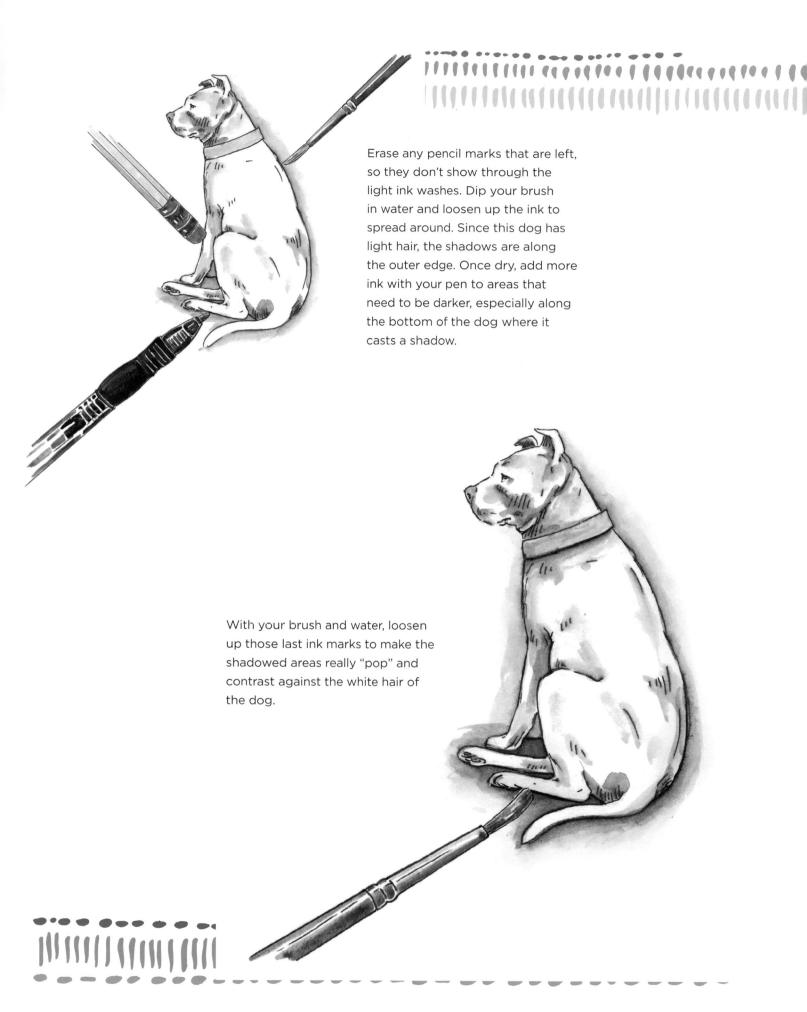

Erase any pencil marks that are left, so they don't show through the light ink washes. Dip your brush in water and loosen up the ink to spread around. Since this dog has light hair, the shadows are along the outer edge. Once dry, add more ink with your pen to areas that need to be darker, especially along the bottom of the dog where it casts a shadow.

With your brush and water, loosen up those last ink marks to make the shadowed areas really "pop" and contrast against the white hair of the dog.

ABOUT
THE ARTIST

CHELSEA WARD is a Southern California native with a passion for making and creating.

In 2010, she graduated from the University of Texas at Austin with a BFA in studio art and moved to Italy for two years. Upon returning to California, she created Sketchy Notions®, a line of unique cards and paper goods, and an Etsy shop of handmade custom treasures. She also teaches art lessons through Arts Outreach and co-hosts Bellissima Art Retreats in Tuscany and California.

Chelsea is also the head chalk scribbler at Chalk by Chels and the owner of Cursive Cursing, a line of swear-word greeting cards.

Visit www.chelseawardart.com to learn more about Chelsea and to view her work.

CLOSING THOUGHT

Regardless of the subject—whether it's a cat sitting in a window or a person holding a flower—be patient and take your time. With just a little practice and your favorite drawing tools, you can draw anything you want to!

Don't forget to visit www.quartoknows.com/page/moderndrawing to download the bonus materials!

Happy modern drawing!